HULL
IN
50
BUILDINGS

PAUL CHRYSTAL

AMBERLEY

For Geoff Chalder, Ian Dickson and Alan Lund – Nicholson Hall,
The Lawns, 1973–76

First published 2017

Amberley Publishing, The Hill, Stroud
Gloucestershire GL5 4EP

www.amberley-books.com

British Library Cataloguing in Publication Data.
A catalogue record for this book is available from the British Library.

ISBN 978 1 4456 6480 4 (print)
ISBN 978 1 4456 6481 1 (ebook)

Origination by Amberley Publishing.
Printed in Great Britain.

Contents

Acknowledgements 4

Hull – 2017 City of Culture 5

Map 6

Key 8

Introduction 9

The 50 Buildings 11

Timeline of Hull 94

Acknowledgements

A number of the photographs and images in this book have been made available by various individuals and organisations. The book would be considerably diminished without their generosity and so it gives me pleasure to thank the following: Steve West and Gordon Stephenson at Reckitt Benckiser Heritage, Hull; I am indebted to J.W. Houlton's *History of the Garden Village Area* for much of the information on the Reckitt Village – it remains unpublished but a copy resides in the Reckitt Benckiser archive and can be read on the Garden Village Society website: www.gardenvillagehull.co.uk; Raymond Needler gave permission to use images and information originally published in his definitive *Needlers of Hull*. All the modern photography is by the author unless otherwise credited.

By the same author:
Hull Pubs
Historic Hull
The Place Names of Yorkshire – Including Yorkshire Pubs
Leeds in 50 Buildings
Leeds's Military Legacy
The Confectionery Industry in Yorkshire
Pocklington Through Time
Secret York
In & Around York Through Time
York Past & Present
The Rowntree Family of York
A History of Chocolate in York
Old Redcar
For a full list please visit www.paul.chrystal.com

Hull – 2017 City of Culture

Hull was named 2017 City of Culture on 21 November 2013. The year 2017 has been split into four seasons with each celebrating a different aspect of Hull's history and culture. *Hull in 50 Buildings* is a fitting testament to the city's status as one of the premier cultural places in the north of the country.

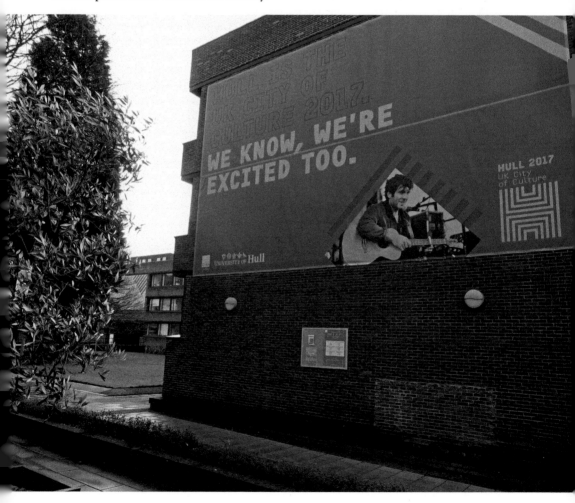

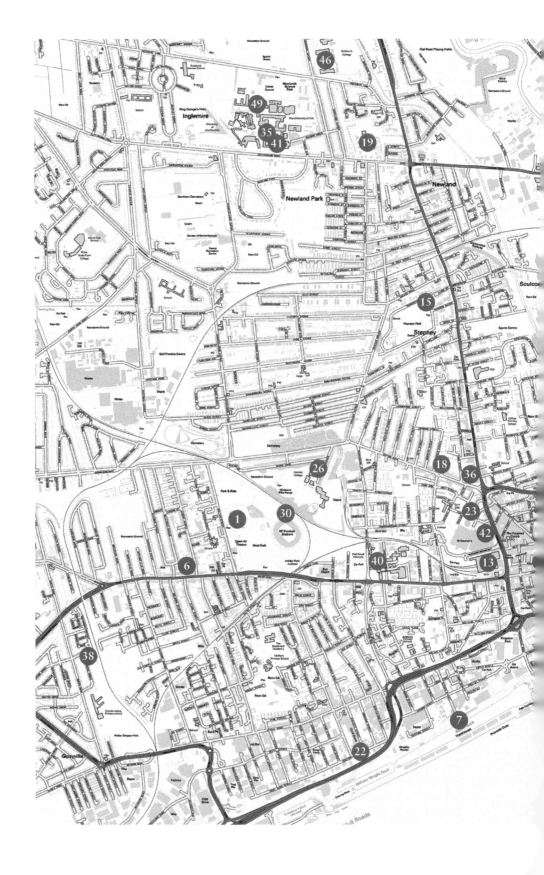

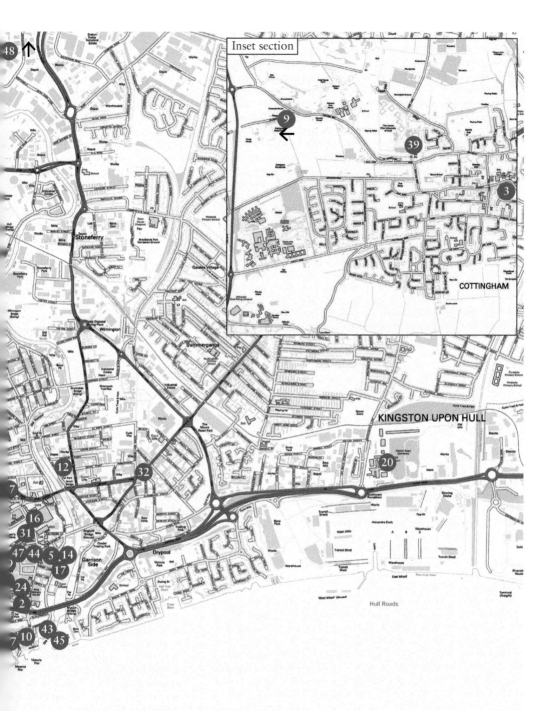

Inset section

COTTINGHAM

KINGSTON UPON HULL

Stoneferry

Wilmington

Summergangs

Drypool

Garrison
Side

Hull Roads

River Humber

Key

1. Hull Fair, 1278
2. Market Place, 1293
3. St Mary the Virgin, Cottingham, 1370
4. Holy Trinity Church, 1425
5. Wilberforce House, 1660
6. Hull Racecourse, 1754
7. Hull Docks, 1778
8. Ferres Hospital Almshouses, 1787
9. Skidby Windmill, 1821
10. The Pilot Office, 1821
11. St Charles Borromeo Church, 1829
12. Reckitt & Sons Ltd, 1840
13. Paragon Station, 1847
14. The Corn Exchange 1856, and the Hull and East Riding Museum
15. Pearson Park, 1860
16. Hull School of Art, 1861
17. Kingston Observatory, 1863, or B. Cooke & Sons
18. Jubilee Primitive Methodist Church (Spring Bank), 1864
19. Sailors' Orphan Homes, 1867
20. Hull Prison, 1870
21. Hull Docks Office, 1871, and the Hull Maritime Museum
22. Fish Dock, 1883
23. Needlers, 1886
24. The Andrew Marvell Statue, 1886
25. The Hull Brewery Co. Ltd, 1888

26. Hymers College, 1893
27. Public Toilets, Nelson Street, 1902
28. The Queen Victoria Statue, 1903
29. Hull Telephone Boxes, 1904
30. The Carnegie Free Library, 1905
31. The Guildhall, 1907
32. The Reckitt Model Village, 1908
33. Hull City Hall, 1909
34. The Ferens Art Gallery, 1927
35. University College/University of Hull, 1927/1954
36. 'Paragon Holiday Homes', 1930s
37. Hull New Theatre, 1939
38. Boothferry Park, 1946
39. The Lawns, Cottingham, 1963
40. Hull Royal Infirmary, 1967
41. The Brynmor Jones Library, University of Hull, 1970
42. Hull Truck Theatre, 1971
43. Hull Tidal Barrier, 1980
44. Hull Combined Court Centre, 1991
45. The Deep, 2002
46. St Mary's College, 2002
47. Hull History Centre, 2010
48. Kingswood Academy, 2013
49. The Allam Medical Building, University of Hull, 2017
50. The Blade, 2017

Introduction

Buildings can reflect history and they can make history. Buildings are the sounding boards of the past, signifying and symbolising a whole range of social, political and religious events that have taken place in them, or in their vicinity. Buildings also make history by virtue of their architectural qualities, breaking new ground in terms of innovation, design, sustainability and materials, and breaking old records in terms of, for example, height or cost.

Hull in 50 Buildings offers a history of Hull through fifty of its buildings, from the markets and fairs of the thirteenth century to the world-beating state-of-the-art Hull York Medical School. Along the way, we illustrate and describe the historical significance of some of Hull's museums, theatres, universities, schools, libraries, a park, a hospital, art galleries, a phone box, two statues, a prison, a couple of businesses, a windmill, a racecourse, a model village, a wind turbine blade and various tourist attractions. Central to the book, of course, are buildings that reflect Hull's rich maritime heritage: the dock office, the pilot office, fish quay, docks, flood barrier, Trinity House and a seamen's orphanage. It's not all grandeur though. We visit a splendid public lavatory and some decidedly low-rent but happy holiday

A superb aerial view of the city with Holy Trinity and the Guildhall clearly visible.

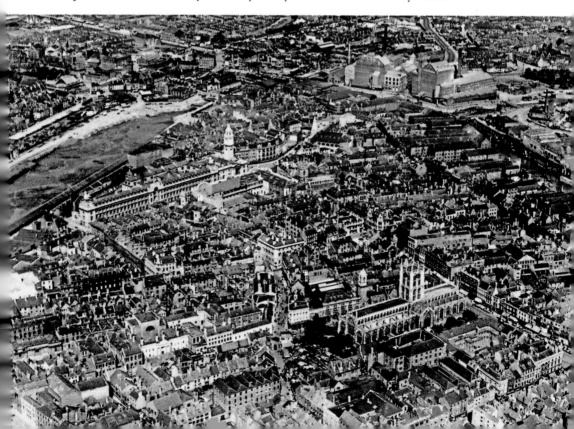

accommodation. Dereliction is not forgotten either, with the destruction caused by the Luftwaffe and a redundant football ground. During the Second World War, Hull was the most bombed city outside of London, with 90 per cent of its buildings damaged to some extent or another.

In 1982 Hull became the first city in the west to twin with a 'third-world' city – Freetown in Sierra Leone; Freetown Way in the city is named to commemorate this. It is hoped that such diversity and inclusiveness continues apace in the Hull of the future and that this is reflected more and more in the architecture, society and ambience of what is now a modern city of culture.

Hull, though, is no stranger to culture or science. Actors Maureen Lipman and Tom Courtenay, TV weatherman Alex Deakin, John Venn (inventor of the Venn diagram) and musicians Mick Ronson and Trevor Bolder (Ziggy Stardust's Spiders from Mars) were all born in Hull. Hull singer Patricia Bredin was the UK representative in the very first Eurovision Song Contest in 1957. The Beautiful South were formed in Grafton Street from The Housemartins; Paul Heaton lived here while the Grafton Hotel served both bands well, apparently inspiring some of their lyrics. There is a track on The Beautiful South's 1989 album *Choke* called 'The Rising of Grafton Street'.

Speaking of pubs, perceptive readers will notice the absence of Hull's glorious watering holes – a serious omission, for, are these not buildings too? Indeed, Hull's pubs and inns count among some of the city's finest buildings and, for that reason alone, they get a whole book of their own – my unimaginatively but precisely named *Hull Pubs*.

<div align="right">

Paul Chrystal, York.

May 2017.

www.paulchrystal.com

</div>

Hull across the Humber.

The 50 Buildings

1. Hull Fair, 1278

We start with Hull Fair – not strictly a building of course but a motley collection of temporary garish structures. However, Hull Fair is such an enduring part of the city's heritage that it would be careless to omit it from this collection on the grounds that its 'buildings' are only ever in the city for one week out of fifty-two.

The fair, now one of Europe's largest and oldest travelling funfairs, has, twentieth-century war years apart, been coming to the city since 1278 and parks up in Walton Street car park, next to West Park and the KC Stadium every year for a week in October. It all started in 1279 when Meaux Abbey was granted an annual fair in Wyke-upon-Hull around the feast of Holy Trinity and for the next twelve days. In 1293 the Sheriff of Yorkshire received orders to proclaim a yearly fair in Hull beginning on the eve of the feast of St Augustine the Archbishop, and lasting six weeks until the eve of the Translation of St Thomas the Martyr, 25 May–6 July. In 1299 Edward I granted the Corporation an annual fair for thirty days from the feast of St Augustine (26 May). In 1598 the St Augustine Fair was abandoned in favour of another from 16 September to 1 October, confirmed by Charles II in 1661.

When the calendar changed in 1751 with the Calendar Act and the loss of eleven days, the people of Hull were outraged. 'Give us back our eleven days,' they angrily cried in the misguided belief that the missing eleven days robbed them of their fair. The mob won the day and from then on 11 October, or the Friday nearest to it, became the official date for Hull Fair.

Fairs in those days were essentially markets and Hull was no different. Gradually the commercial elements diminished to be replaced by attractions, which enabled people simply to have a good time in what had become a pleasure fair. Before that, though, the allocation and location of stands was standardised: in 1440 it was ruled the stands for horses was in the Ropery, later Humber Street, cattle were in Mytongate, sheep in Salthouse Lane, and merchandise, mercery, and craftsmen in the marketplace between Guildhall and Whitefriargate. The sheep fair was held on 22 September in Mytongate; Londoners, grocers, mercers and goldsmiths set up their stands in High Street, from North Gate to Chapel Lane end. Founders, pewterers, pedlars, shoemakers, linen drapers, glovers and hardware men all had their stands in Salthouse Lane. In 1599 the cattle stand was 'all along the manor walls' from the sewer in Denton Lane to Bishop Lane end. In 1630 the plague meant that Lincolnshire visitors could not attend the fair without certificates of health, and in 1631 the fair was cancelled because of the plague.

In the eighteenth and early nineteenth centuries, the fair featured jugglers, theatrical booths, puppet shows and the famous Bostock and Wombwell's Menagerie, which gave many of the people of Hull their first experience of wild and exotic animals. Less palatable

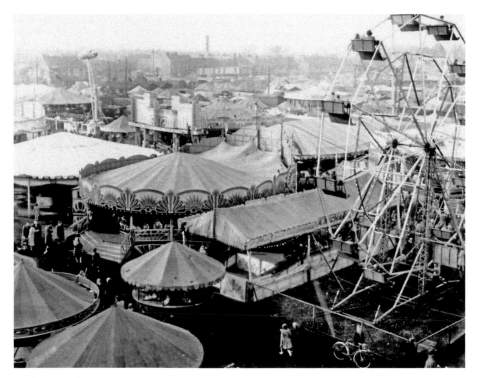

Hull Fair in the 1950s.

to us today were the freak shows in which disabled, deformed and fat people were exhibited along with hermaphrodites, dwarfs and giants. In 1815 William Bradley, the Yorkshire giant from Market Weighton, drew in the crowds. In the 1870s mechanisation gave Hull Fair a new lease of life with the introduction of steam-powered carousels, ferris wheels, waltzers, ghost trains and speed.

Before settling at Walton Street in 1888, the fair was held variously in Nelson Street, Wellington Street, Queen Street, Market Place, and Brown Cow Field before it moved to Park Street in 1865 on the Corporation Field. The locals in Park Street were not very happy about this annual invasion and 'condemned the disgusting amount of fat females exhibited and the peep shows, which in their opinion bordered on the obscene … adding that the quantity of catarrh caused by the sloppy condition of the fairground is unlimited'.

The move to Walton Street, however, was also problematic with many show people anxious that attendances would fall. However, one of their number, Randall Williams, who regularly came to the fair with his ghost show, came up with a novel idea to draw the crowds to Walton Street. He organised a resplendent funeral cortege to travel from Park Street to Walton Street; it comprised a cut-glass hearse, drawn by four black Belgian horses all accompanied by mutes and weepers. The parade set off from Park Street and trundled through the streets of Hull, followed by increasingly large crowds gawping in wonder and fascinated to know what celebrity occupied the coffin. When the cortege arrived at Walton Street, Randall Williams leapt out, bowed to the multitudes and pronounced, 'Now you know where Hull Fair is!'

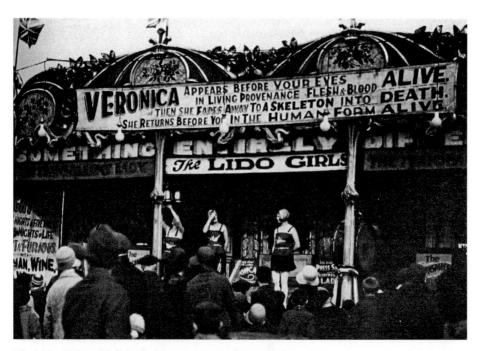

The Lido Girls at Hull Fair – strange women to say the least.

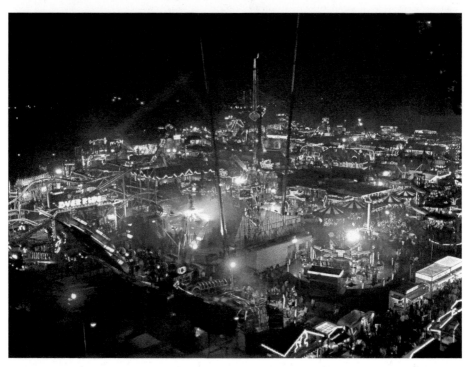

Hull Fair at night, taken on Friday 13 October 2006 from the top of the 'Big Wheel'. (© Reginald Herring under the Creative Commons)

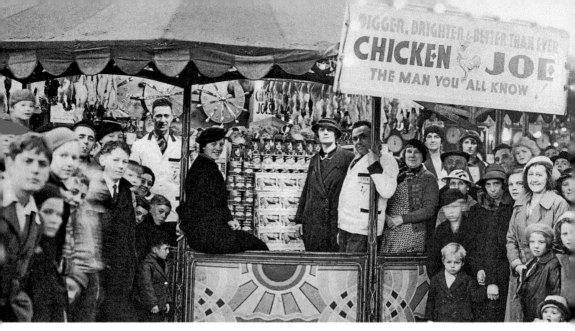

Chicken Joe, mobbed again.

By the end of the nineteenth century, fair goers could enjoy a ride on Green's Switchback Gallopers, Marshall's Bicycles or Tuby's Galloping Horses, as well as Proctors and Baileys Circus or William's Ghost Show. In 1897 Randall Williams put on 'living pictures' in his Ghost Show, one of an increasing number of bioscope shows.

Success and popularity continued to grow and 1908 saw twenty-seven railway excursions bringing over 12,000 people to Hull Fair. Electricity too had arrived, prompting the show trade magazine *World's Fair* to describe Hull as 'Light City'. Menageries and cinematographs, and Chipperfield's Elephant Boy were all the rage in 1912. In the '30s and '40s Chicken Joe, real name Joe Barak, was a legend and a star attraction. His appeal lay in the fact that the bingo prizes he offered were not the usual tat, but groceries and live chickens in a brown paper bag. Chicken Joe – the man we all know – was a Yorkshire showman who had the sensible idea of offering something to his customers that was actually useful, particularly in times of rationing.

2. Market Place, 1293

At the same time as Meaux Abbey was granted a fair in 1279, the monks there were also granted a weekly market on Thursdays in Wyke; then in 1293 two weekly markets were established in Hull, on Tuesdays and Fridays. Naturally, specific areas were allocated to different commodities. At first the market was held on either side of Marketgate, parts of which were later named, for obvious reasons, as Butchery, Market Place, and Lowgate. In 1469 it was all restricted to south of Whitefriargate, Silver Street and Scale Lane.

The period between 1762 and 1771 saw the street enlarged, facilitated in 1792 by the demolition of buildings around Guildhall in 1792. In 1804 Butchery was widened and renamed Queen Street, then extended south to Ferry Boat Dock; Humber Street,

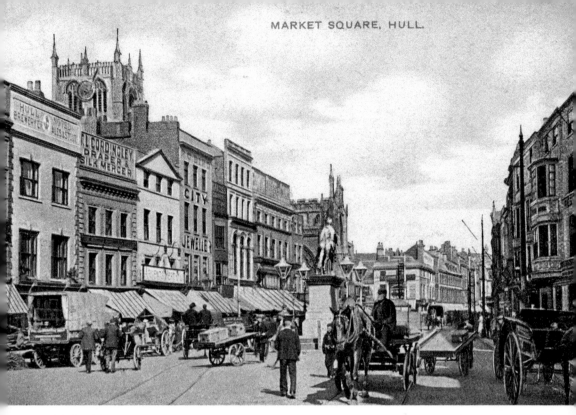

Market Place.

from Queen Street to Humber Dock, became an extension of the market. Two market halls were built to reduce crowding: the first, on the site of the butchers' shambles at the junction of Blackfriargate and Queen Street, opened in 1887 boasting 109 stalls and twenty shops. In 1941 the Germans bombed it to destruction – stallholders were accommodated in the North Church Side Hall, which in 1962 contained ninety-eight stalls. The second hall was mainly for fruits, flowers, and vegetables; it opened in 1904 on North Church Side. By 1928 it contained seventy-four stalls.

Market Place's market cross was erected around 1498–99; in 1640 it stood at the south end of the marketplace. It was taken down in 1761. There was also a bull ring in the marketplace from 1522 on the south side of the cross, moving in 1734 to Lowgate on a site later occupied by the statue of William III.

Meat Market

Butchery (*bocheria*) was first recorded in 1337 – the same place as the *via carnificis* noted from 1340, the Fleshewergate of 1383, and the Fleshmarketgate of 1393. Both local and 'foreign' butchers set up their stalls there until 1440 when the 'foreign' butchers were moved to the 'New Butchery' in 'the Dings' – shops or stalls below street level, on the west side of Market Place. In 1634 the fish shambles were moved to the Butchery meaning that butchers had to occupy various parts of the marketplace itself – the 'White Meat Market'.

In 1806 the old shambles were rebuilt between Fetter Lane to the north and Blackfriargate to the south. In 1834 these were covered over and space was made for butter and egg sellers.

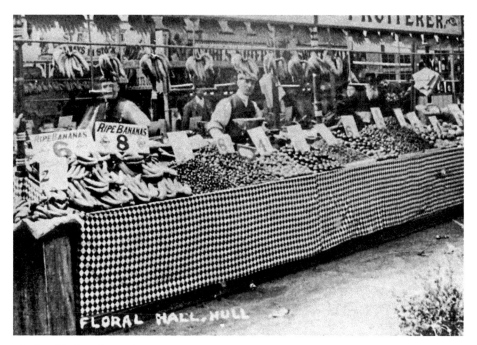

The floral hall in the market.

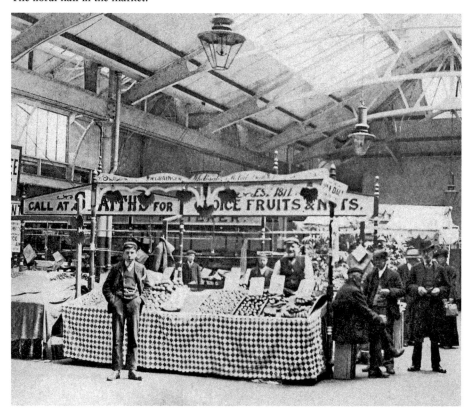

Fish Market

Fish sales were first recorded in 1515 when fish shambles were built in what later became, aptly enough, Fish Street. Fresh sea fish were sold separately from salt fish and fresh-water fish. As we have seen, in 1634 fish shambles were moved to the Butchery – from 1756 the sale of all fish, herrings excepted, was restricted to these shambles. In 1805 new fish shambles were opened in the Ropery, moving in 1856 to the former site of the corn market behind the butchers' shambles. The explosive growth of the fishing industry in the mid-nineteenth century led to the provision of wholesale markets. In 1888 the harbour commissioners established a fish market at the docks and in 1895 a wholesale market was at Paragon Station.

Corn Market

In 1640 corn was traded at the junction of the marketplace and Mytongate, moving in 1778 near to the butchers' shambles, where it was supervised, from 1785 onwards, by two members of the Corporation. In 1814 this site was sold and in 1816 the market moved to the south end of the new meat shambles, although the area it occupied was not partitioned off until 1828. The old market, nevertheless, continued in use until at least 1828. In 1856 it was rehoused in a new building, on the site of the custom house in High Street. The imposing façade owes everything to a Roman triumphal arch; its central bay is flanked by fluted, Corinthian columns rising over two floors. In 1925 it was converted into a museum while 1945 saw the corn market move to the cattle market.

Butter Markets

In 1608 the salt butter sellers were at the west end of Church Lane. In 1682 the market was under the Guildhall, moving in 1692 to a yard in Lowgate. Fresh butter, however, was sold from buckets near the market cross in 1716, moving to the new butchers' shambles in 1834.

Livestock Markets

We first hear of livestock markets in 1599 when regulations were made restricting the sale of cattle, horses, and sheep to the summer months. In 1679 the sheep and beast market was relocated to Fish Street, and in 1782 it moved again to Tan House, later Waterhouse Lane, in separate markets. In 1818 this was all sold to the Dock Co. to develop Junction Dock. Around 1838 a new cattle market opened in Edward's Place, which in 1928 was a two-storey building housing pigs and sheep as well as cattle. Pigs were sold in the marketplace from the sixteenth century; Pig Alley, which ran from Blanket Row to Back Ropery, was probably the site of an earlier pig market. Pigs could later be sold at the cattle market in Edward's Place where there were fat pig pens – a separate store pig market, at the junction of Wood's Lane and Cogan Street, was opened in 1915. In 1928 Hull pig market was the fourth largest in the North. It was not before 1964 that a public abattoir opened in Edward's Place.

Fruit, Flower, and Vegetable Market

You could buy fruit in the marketplace from the end of the sixteenth century, and vegetables from the beginning of the seventeenth century. The year 1640 saw the fruit market situated to the north of Holy Trinity Church, but in 1752 fruit and vegetables were sold together at the south end of the marketplace. Since 1904 fruit, flowers and vegetables were usually traded in the market hall, but from 1965 stalls stood in the general open market on market days as well. A wholesale fruit and vegetable market took place in Corporation Field, Park Street, in 1888 – open on Tuesdays and Fridays in 1928. From 1961 it was held at the cattle market. There were

two private wholesale fruit and vegetable markets in 1928: one on Riverside Quay was owned by the L&NE Railway and was held on Mondays, Wednesdays, and Thursdays from May to September but more frequently during the soft fruit season; the other was in Humber Street.

Wool, Hide, and Skin Wholesale Markets
There was a wholesale market trading wool, held every week in June and July, in the NE Railway warehouse in Kingston Street from 1841 to 1895. In 1888 an annual sale of wool was started in a shed in the cattle market.

General Markets
In 1395 and throughout the century until the mid-fifteenth century, drapers were confined to selling their goods in 'the Dings'. In 1566 there is a record of a bread market in Market Place. In 1752 the bakers' stand was to the south of the cross, between the butchers and the fruit sellers. In 1608 other traders who had stands in the market were pedlars, chapmen, glovers, linen cloth sellers, goose and egg sellers, cutlers, knife sellers, hardware men, candle sellers, and woodwork sellers. In 1818 the earthenware sellers occupied a stand in Queen Street below Blackfriargate. In 1888 the NE Railway permitted its customers the use of the station as a market of sorts for game, hares, and rabbits. Drapery was the main commodity in the open market on the 134 uncovered stalls near Holy Trinity Church in 1928.

3. St Mary the Virgin, Cottingham, 1370

The large cruciform stone-built Cottingham parish church was built between 1272 and 1370 in the Decorated and Perpendicular Gothic styles. The tower was built in the fifteenth century, pinnacles were added to the tower in the eighteenth century and an adjoining workhouse known as the 'Church House' was built in 1729.

The church is one of the focal points of what is a very large village, swelled by the accommodation of thousands of Hull University students at The Lawns, Needler Hall and Thwaite Hall. Cleminson Hall was demolished after 2003 to make way for housing in 2012.

Snuff was big business in eighteenth-century Cottingham; Quaker William Travis built a large mill that was turning out fifteen hundredweight of snuff every week. His three-storey house was built in 1750 next to the mill, Snuff Mill House. The population of the village in 1792 was 1,178 in 284 houses. By then it was a centre of market gardening and boasted two breweries and a carpet factory from 1811. The Provincial Gaslight and Coke Co. opened in the 1850s and built a gasworks. The site was used for a cloth mill, Station Mills, in the last century. Philip Larkin is buried in Eppleworth Road Cemetery, which opened in 1890. Between 1913 and 1916 Castle Hill Hospital was developed on the site of Cottingham Castle House, along with a tuberculosis sanatorium. Between 1921 and 1939 an infectious diseases hospital was added. In 2009 the Queen's Centre for Oncology and Haematology and a cardiac unit opened; a cancer centre for teenage patients was established in 2011.

Cottingham is blessed with numerous public houses – to the delight of both town and gown. They include the Black Prince on The Parkway, The Blue Bell and The Fair Maid (formerly Westfield House) on West Green, The Duke of Cumberland on the market square, the Cross Keys on Northgate, The Railway on Thwaite Street, The King Billy (King William IV), Hallgate Tavern on Hallgate, and The Tiger on King Street.

St Mary the Virgin, Cottingham.

4. Holy Trinity Church, 1425

We have Edward I (r. 1272–1307) to thank for Holy Trinity; it was he who realised the strategic importance of a town at the confluence of the Hull and Humber, bought the land and set about building his King's Town upon Hull. A proper church was high on the construction agenda to replace an early chapel and so his masons set about constructing what was to be one of the greatest of the great churches of the English medieval period. It is the only building to survive from the original 'King's Town' and formed the template for all subsequent parish church buildings in the Perpendicular period. Holy Trinity is the oldest brick-built building in Hull still in use in its original purpose. It is the largest parish church in England by floor area and contains some of the finest mediaeval brickwork in the country, especially in the transepts. In the mid-1300s wealthy merchants, including the de la Pole family, added a Perpendicular nave and widened the chancel. It was finally consecrated in 1425.

In June 1915 Zeppelins dropped a bomb nearby – Holy Trinity was only saved by a change in wind direction and the fire services. In March 1916 windows were shattered during another raid; one window provides a reminder of that evening with a mosaic of glass made up from the damaged windows. During the Second World War, Holy Trinity served as an air-raid shelter. It was also a navigational marker for the German planes, which may account for its survival. Today, the north choir aisle is a memorial space for a number of military organisations, and for Hull's trawler men lost at sea. On 7 November 2016 Archbishop of York John Sentamu announced that Holy Trinity would be accorded minster status in a ceremony on 13 May 2017.

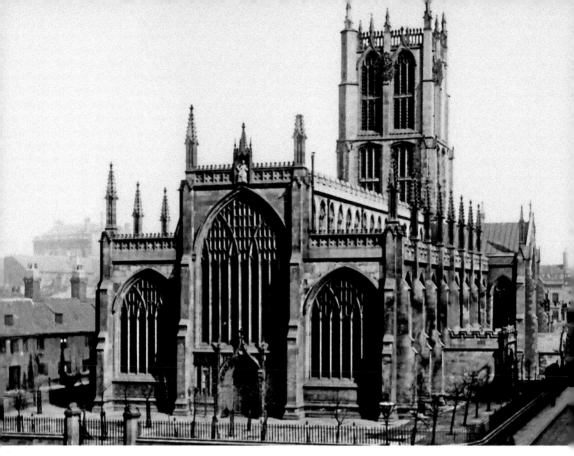

Above: The magnificent Holy Trinity.

Below: Holy Trinity reflected in March 2017.

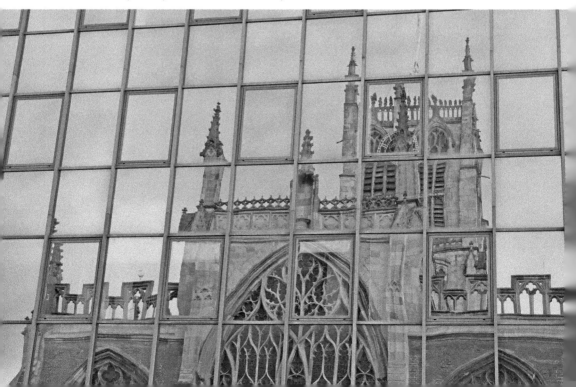

5. Wilberforce House, 1660

Wilberforce House at No. 25 High Street is Hull's oldest surviving museum. It opened in 1906 and takes its name from William Wilberforce, the abolitionist who was born here in 1759. The museum is dedicated to Wilberforce and his campaign to abolish the slave trade.

The building was originally constructed in the 1660s for one of the Listers, a family of Hull merchants. Sir John Lister entertained Charles I here on his first visit to Hull. In 1709 the house passed to John Thornton, a prominent exporter of cloth and lead at that time. One of Thornton's apprentices was William Wilberforce, who had moved to Hull from Beverley to work. This Wilberforce was the grandfather of the abolitionist, who married his master's daughter in 1711. The house passed to Wilberforce in 1732, while the family made their fortune in the Baltic trade.

The following are the eight galleries:

The History of the Building – the history of Wilberforce House.

The William Wilberforce galleries shine a light on Wilberforce, following his life and political career, with original artefacts, costume and documents.

The West African galleries illuminate the cultural traditions of various African societies, their religion, ceremonies, music and adornment.

The Capture and the Middle Passage galleries depict the horrors of being kidnapped and transported across the Atlantic.

The Plantation Life galleries explore what life was like for enslaved Africans sold to work on plantations in the Caribbean and the Americas. It portrays appalling working conditions, health, punishment and death, as well as how plantation workers rebelled and resisted.

The Abolition galleries examine the campaigns to abolish the slave trade and slavery, and what happened after emancipation. The gallery features the famous Brooke's slave ship model used by Wilberforce in the Houses of Parliament.

The Contemporary Slavery galleries show the repellent slavery that goes on in the twenty-first century and the efforts being made to stop it.

The Georgian Town Houses Gallery displays local craftsmanship in silverware, clocks and furniture.

Wilberforce, however, was not just an abolitionist: the Wilberforce Memorial was the charity behind the Yorkshire School for the Blind in York. It was established in the King's Manor on the death of William Wilberforce in 1833, out of a desire to honour his memory and good works. Wilberforce had represented Yorkshire as an MP for twenty-eight years and was an influential voice not just for the movement to abolish the slave trade but also for the education and training of the blind. The school's mission was

> To provide sound education together with instruction in manual training and technical work, for blind pupils, between the ages of five and twenty; to provide employment in suitable workshops or homes for a limited number of blind men and women who've lost their sight after the age of sixteen, in some occupation carried on at the school; and to promote such other agencies for the benefit of the blind as may enable them to gain their livelihood, or spend a happy old age.

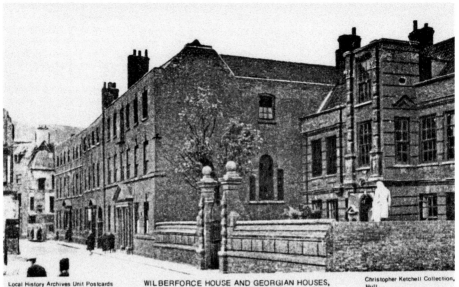

Local History Archives Unit Postcards
No.37 William Wilberforce
(ISBN 1 870001 14 1)
Humberside College of Higher Education

WILBERFORCE HOUSE AND GEORGIAN HOUSES,
HIGH STREET, HULL.
FOLLOWING BLITZ DAMAGE IN 2ND WORLD WAR.

Christopher Ketchell Collection,
Hull.
(Original postcard "Brombys
Views of Hull" n/d (1950?).

Wilberforce House in 1946 and 2017.

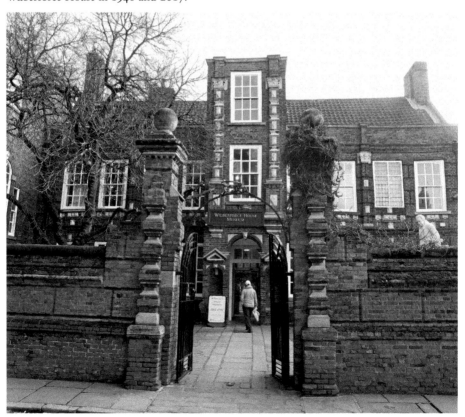

6. Hull Racecourse, 1754

Beverley was not always the only local racecourse. Hull racecourse is well attested from 1754 when the nonconformist Mary Robinson refers to it, and to the evening entertainment to be had there, in a letter to her husband in July of that year: 'thare was a deal of very good Company at Hull in the Race weak. Miss and me was thare two nights and one morning at the Concert and three days upon the feald'.

Jeffrey's 1775 map of Yorkshire shows the Race Ground in Newington to the north of the Anlaby turnpike road. From 1770, the *York Courant* ran advertisements for the three-day Hull Races every July or August. The runners were registered at the King's Head in Mytongate, where pre-race cock fights would take place. By 1777 the ground had 'new stables, built at Newington, adjoining the ground'. The *Hull Advertiser* of 25 June 1796 informs us,

> HULL RACES, for 1796 – Three races held over three days, Tuesday, Wednesday, Thursday, 26, 27, 28th July, 1796, prizes of £50 for two of the races and the Town's Plate of £50 for third. SIR C. TURNER, Bart, Steward. The horses to come to Mr. Leonard's Stables, opposite the first mile stone on the Anlaby Turnpike from Hull leading to the Race Course. Entrance Three Guineas each & Ordinaries and Assemblies as usual, Horses to be entered at Mr Hollom's booth.

James Sheahan, in his *History of Hull* (1866), writing about recalling the 1796 Hull Races, noted, 'there was but one race each day, in heats ... one of the jockeys, a man named George

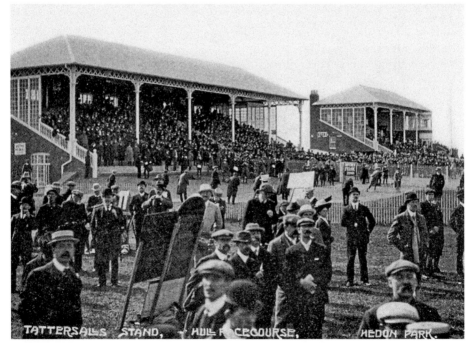

Hull Racecourse.

Heron, was killed on the second day by being thrown from the horse he was riding in the race'. *A History of Hull* by Gillett & MacMahon says,

> Horse-racing, popular for many years, continued on the Wold Carr, in Newington, often with as many pickpockets as gentleman, the races were salubrious enough to attract Lord Milton, Daniel Sykes of Raywell, and W J Denison – High Sheriff of Yorkshire.

In 1839 the *Hull Advertiser* newspaper reported that the races 'had been well attended 40 years ago'. Horse racing on the old racecourse was a thing of the past but 'trotting races' still took place on the Anlaby Road. In 1841 at least one 'Pony Race' was held on the Anlaby Road.

The Royal Agricultural Show was held on the site of the old course in 1873 and 1899, and the Yorkshire Show in 1904. West Hull Tennis Club, S. W. Liberal Tennis Club, West Hull AFC, and North Newington Church Tennis Club all used the land at one time or another. When the course closed in 1909, the site was used as an airfield.

7. Hull Docks, 1778

The Haven (Old Harbour) is the lower part of the River Hull as it flows towards the Humber. From the earliest days this was the main assembly point for vessels loading and unloading their cargoes but, as the numbers of boats increased in volume and size, the busy waterway became overcrowded. To cater for this, the first enclosed dock was completed in 1778, although its excavation necessitated the removal of the northern section of the city's walls. This was followed by the Humber Dock in 1809 and the Junction Dock (Princes Dock) in 1829. The series of docks followed the line of the old city walls, which were removed.

The town docks system was extended in 1846 with the construction of the Railway Dock, its use monopolised by the Wilson Line, then Hull's biggest steamship company.

The Victoria Dock was opened in 1850 with timber as its main commodity, imported largely from the Baltic. The Albert Dock opened in 1869 for general cargo, also becoming home to the North Sea fishing fleet, while in 1883 St Andrews Dock, originally intended for the coal trade, absorbed the increase in fishing with an extension added in 1897.

The Alexandra Dock opened in 1885. A riverside quay was established in 1907 south of the Albert Dock so that ships with perishable cargoes could be unloaded promptly.

The fictional castaway Robinson Crusoe set sail from the Queen's Dock in Hull – there is a plaque in Queen's Gardens to commemorate this.

The 1930s saw the Old Dock (called the Queen's Dock from 1854) filled in while the rest of the city centre docks closed in the 1960s. The Humber and Railway docks were converted into the Hull Marina in the 1980s. Further east still, the King George V Dock opened in 1914 and most recently the Queen Elizabeth Dock in 1969. King George V Dock is the home of the North Sea ferries for Rotterdam and Zeebrugge.

Today, HumberPort is the UK's largest port complex, handling 1 million passengers and processing 90 million tonnes of cargo.

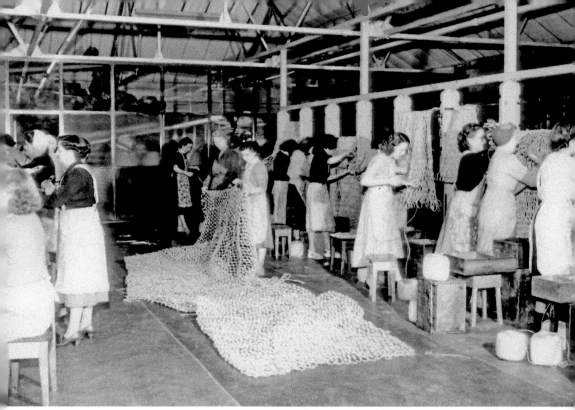

Above: Net making at the docks in 1955.

Right: More busy dock work.

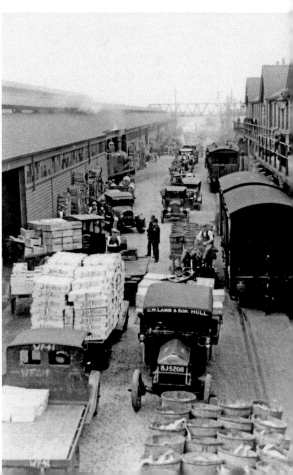

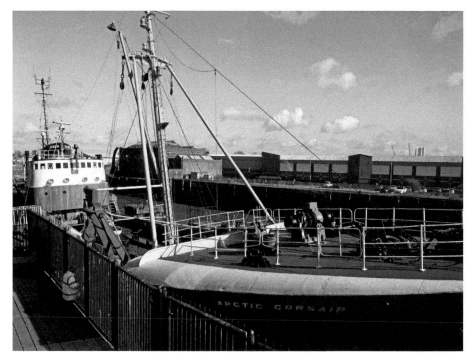

The *Arctic Corsair* was built in 1960 at Beverley Shipyard for the Boyd Line. She was a veteran of the Cod Wars and was rammed by an Icelandic gunboat in the 1970s. Laid up in 1987, she became a floating museum in 1999.

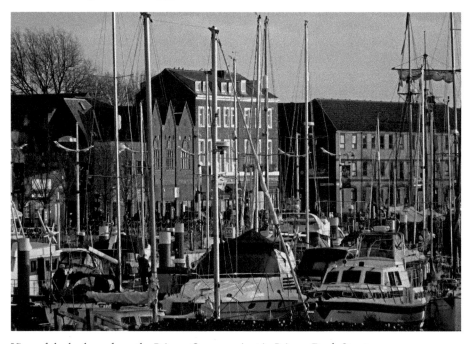

View of the harbour from the Princes Quay precinct in Princes Dock Street.

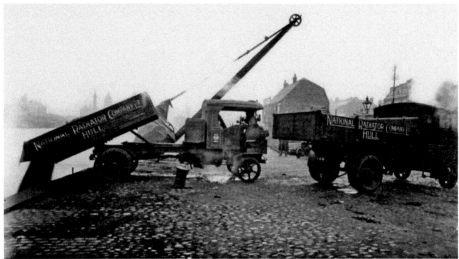

Local History Archives Unit Postcards
No.38 Transport
(ISBN 1 870001 18 4)
Humberside College of Higher Education

NATIONAL RADIATOR Co's STEAM LORRIES
FILLING IN QUEEN'S DOCK, HULL c.1930

Photograph reproduced by
permission of Mr. G. Edwards,
Keyingham.

Filling in Queen's Dock.

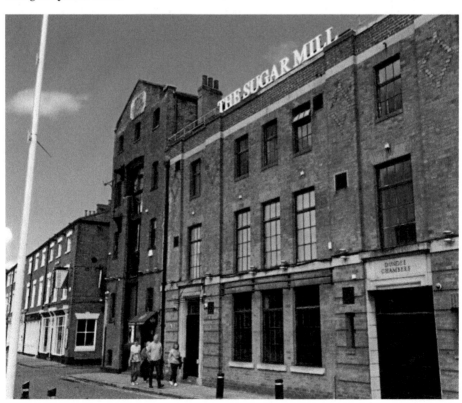

The Sugar Mill in Princes Dock Street – one of Hull's finest clubs. Before 2007 it was called the Waterfront. (© Alan Lund)

8. Trinity House 1753, and Ferres Hospital Almshouses, Roland House, 1822

Hull Trinity House comprises the Corporation of the Hull Trinity House and the Hull Trinity House Charity. The charity serves seafarers and their families. The Trinity House School, now an academy, and the Corporation is made up from the Guild or Fraternity (Brotherhood) of Masters, and Pilots, Seamen of The Trinity House in Kingston upon Hull.

The year 1369 was a pivotal one when forty-nine men and women formed a guild in honour of the Holy Trinity. At the core of the guild was their pledge to be present in the Hull's Church of the Holy Trinity on the day of the Holy Trinity, to carry the guild's candles, and to help each other in poverty and sickness. A brother or sister unable to support himself or herself was to be paid 8*d* a week, and, at the Feast of St Martin, to be given 'a tunic and a little cap'. If more was needed, a collection was made to proffer further support. They also pledged to attend the funerals of deceased members and to say mass and to make offerings for the soul of the deceased. Four tapers were to be kept burning and thirty masses said for the soul within the first week after burial. Two tapers were to be burnt if a member's child died.

If any member fell into arrears with his or her subscription, the amount to be repaid was double whatever was owed. For troublesome members the fine was 2 lbs of wax; there was also a penalty of 1 lb of wax for any absences from church on the Day of the Holy Trinity, or for not attending funerals or for not saying mass.

Zebedee's Yard named after Zebedee Scaping, a former headmaster of Trinity House School.

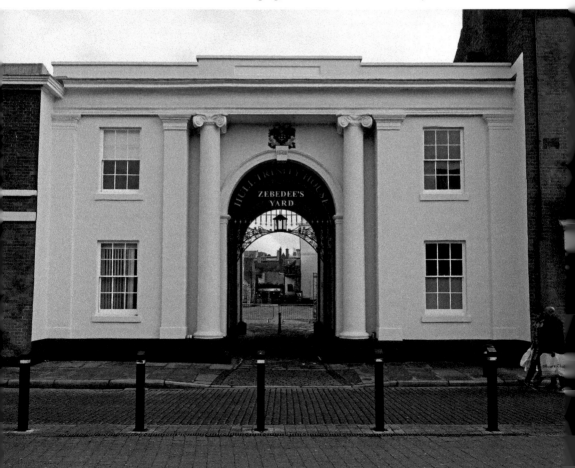

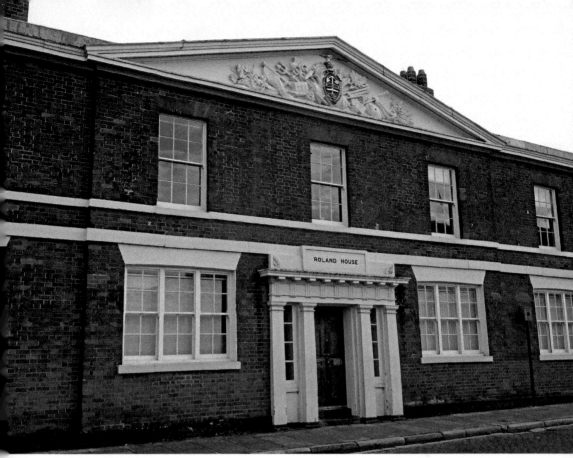

Above: Commercial Chambers, Roland House, No. 24 Princes Dock Street.

Right: The swing pole in the schoolyard, which was used for exercise.

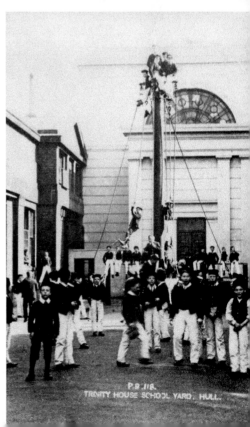

Trinity House has administered almshouses since 1457 as it still does to this day, providing sixty-four rest homes for needy seamen or their widows. It pays pensions to 700 persons who qualify for them. The income for the support of the pensioners and almshouses is derived from the Carmelite Estate. Trinity House also owns a number of farms in East Yorkshire, which support the guild and the charity.

In the wake of the Dissolution of the Monasteries between 1536 and 1541, land owned by the Carmelite Friars became Crown land and was bought by Thomas Ferres, an elder brother of the guild, who gifted it to the Guild or Fraternity (Brotherhood) of Masters, and Pilots, Seamen of The Trinity House in Kingston upon Hull in 1621.

A school for mariners eventually opened in 1787; students learned reading, writing, Latin and Greek, accountancy, religion, and navigation for three years after which they were apprenticed. The Trinity House building was rebuilt in 1753, and a guild house added in 1775. Statues of Neptune and Britannia stand sentinel above the main entrance, with the building forming a square around a courtyard and almhouses around it.

In the next century the school took on the management of the harbour at Hull, and was responsible for buoys and pilotage in the Humber. The Humber Conservancy Act of 1852 restricted its operations; rights of lowage, stowage, and exclusive rights of pilotage were lost but the guild continued its charity work and the provision of education, both of which continue to this day. Today Hull Trinity House Charity supports mariners and their families, and runs rest homes and Welton Waters Adventure Centre.

In 2012 the school was made an academy. The site of the old school is now an events area called Zebedee's Yard. In 2013 the school moved to George Street into the refurbished Nautical College Building, a former university building, and the Derek Crothall Building, which was part of the University of Lincoln.

The house is still very much a 'working' building, but it also contains a treasure trove of artefacts and memorabilia donated by Brethren over the years, making it a museum in its own right. The floor of the Council Room is still strewn with reed straw, just as all the rooms in the building used to be, to soak up the filth and dust from the unpaved streets of the city. The Cook Room is dedicated to Capt. James Cook and his voyages, financed in part by wardens and brethren of the house. A small museum contains many rare objects.

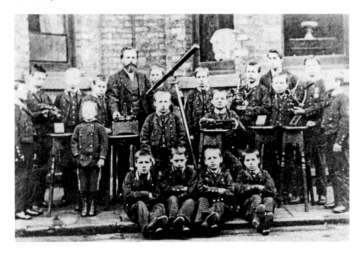

A nautical astronomy class with headmaster Zebedee Scaping, around 1873.

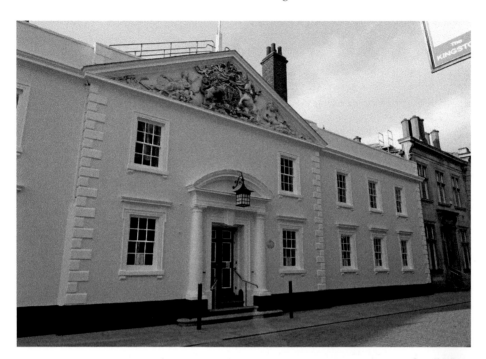

Trinity House and its magnificent
pediment in March 2017.

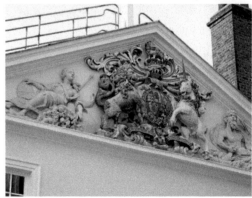

The present Trinity House buildings were built in 1753 and completed with the addition
of the pediment in 1759. The original chapel is now used as the main office. The guild still
uses the Reading Room, Council Room, Canoe Room and Court Room. Trinity House holds
all personnel fishing records for the Hull Fishing Fleet from 1946 onwards until its demise.
They can trace every voyage, even when an individual worked on vessels of different owners.

In 1822 Ferres had founded an almshouse, Ferres' Hospital in Prince's Dock Street. The
original building on the site had been taken over in 1461 by the Carmelites to accommodate
thirteen pensioners, with rent payable to the Carmelites at 1s per year. Some family rooms
were available.

Anchor House in Anlaby Road is a 1931 Roman Catholic institution – a sailors' hostel
that is the Hull branch of the Apostleship of the Sea. The present premises in Anlaby Road
were taken over in 1951, with extensions in 1957 and 1965.

9. Skidby Windmill, 1821

The last working mill in East Yorkshire, the four-sailed tower Skidby Mill was built in 1821 and has been restored to its present imposing situation just outside Cottingham. Skidby Mill replaced an earlier post mill on the site. From 1854 until 1962 the Thompson family owned the mill, as well as a steam roller mill in Hull and a water mill at Welton, east of Hull.

Skidby Mill survived the Great Agricultural Depression at the end of the nineteenth century. It was then given over to the production of animal foodstuffs by raising the mill tower, building additional outbuildings and installing new animal feed machines – changes which allowed Skidby Mill to thrive. The sails were disconnected and electric machinery installed in 1954. In 1974 the mill was fully restored to working order using wind power.

All of the original outbuildings are intact and form part of the fascinating Museum of East Riding Rural Life. In the two exhibition galleries, the Agriculture Gallery displays the agricultural history of the East Riding, while the Village Life Gallery shows aspects of rural village life. There is also an intriguing display of veterinary tools and restored animal feed machines. On the flour-bagging floor, visitors can see the major restoration work carried out on the mill between 2008 and 2010.

Skidby Windmill in 2017.

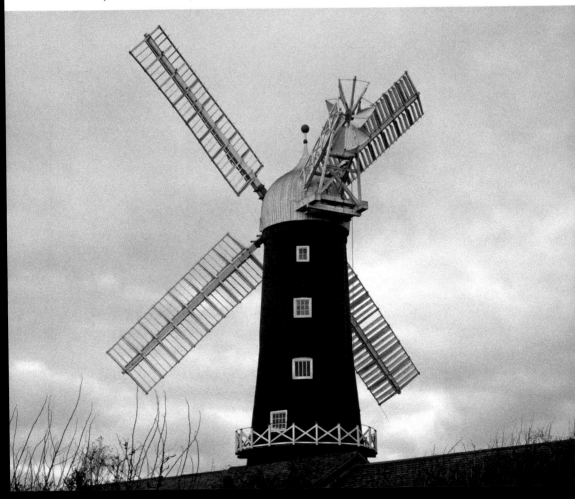

10. The Pilot Office, 1821

The perils associated with navigating the Humber Estuary are well attested; shifting sands were a deadly hazard. Indeed, a 1693 British sea atlas prefaces its directions for sailing into the Humber with this warning: 'To sail into the River Humber you must have a care of the Dreadful-Sand which is but 6 and 7 feet at low water.' Pilotage was crucial then and provided by Hull Trinity House. Even Henry VIII got involved when he watched a Scottish vessel unsuccessfully trying to enter the port. After that all 'strangers' (foreign vessels, including Scottish ships) had to be brought in by a brother of the Hull Trinity House. In 1821 the Pilot Office was built at the corner of Nelson Street and Queen Street,

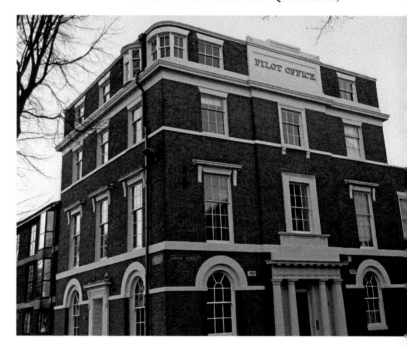

The Pilot Office.

The elegant Humber Ferry offices nearby, closed in 1981.

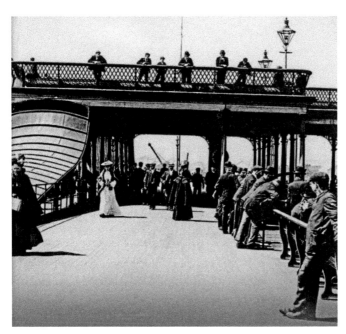

The pier.

serving as the central office for the Humber pilots until 1998 when the building was sold off for redevelopment as apartments. Humber pilots were self-employed until 2002 when Associated British Ports broke centuries of tradition by directly employing the pilots.

11. St Charles Borromeo Church, 1829

Towards the end of the eighteenth century there were probably around 100 Catholics in Hull. The first post-Reformation Catholic chapel was built in Posterngate after the first Relief Act of 1778, but this was destroyed in 1780 during the Gordon Riots. It was rebuilt as a Jewish synagogue. Worship was henceforth conducted in secrecy. Fleeing the turmoil of the French Revolution, a French émigré priest, Abbe Foucher, built a chapel in North Street in 1799, while his successor, Father John Smith, planned the new church of St Charles Borromeo in Jarrett Street. However, it was considered something of a disappointment, so J. J. Scoles was commissioned to alter and widen the church, which reopened in 1835. There were more changes in 1894 when the Corinthian column porch was added and it was made to look decidedly more Catholic throughout the interior. A papal coat of arms is in the pediment and niches either side of the porch contain statues of St Charles Borromeo and St Margaret Clitherow.

Parishioners were buried in the walls of the crypt here from 1829 to 1849, the practice ending possibly because of a cholera epidemic when the cemeteries in the city were more accessible. The bones of White Friars, discovered during nearby building work excavations, were interred in a wall tomb here as well as bones from a dig in Blackfriargate.

The church exudes Italian baroque and Austrian rococo styles. Its opulent features include a vast painting of the Last Judgement above the high altar, framed by Ionic columns and gilt and painted organ pipes. The carved marble of the altar depicts scenes from the life of St Charles Borromeo, illuminated by daylight shafting in from a dome in the roof.

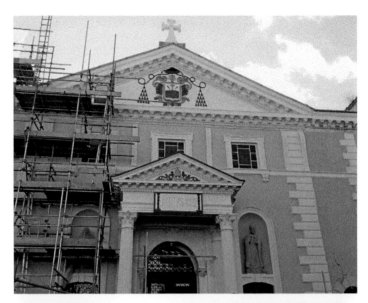

St Charles
Borromeo Church
getting a facelift in
March 2017.

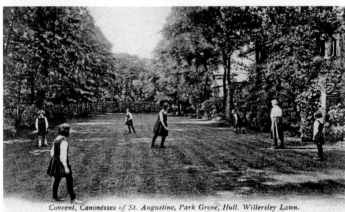

Convent, Canonesses of St. Augustine, Park Grove, Hull. Willersley Lawn.

Canonesses of
St Augustine in
Park Grove.

St Charles Borromeo was born on 2 October 1538 at the castle of Arona on Lake Maggiore near Milan. His father was the Count of Arona and his mother a member of the House of Medici. His uncle, Cardinal Giovanni Angelo Medici, was elected Pope Pius IV on 25 December 1559. The new pope invited his nephew to Rome and appointed him as a cardinal deacon; a month later, Pope Pius IV made him a cardinal.

The convent of the Sisters of Mercy was founded in 1857 in Anlaby Road, near the end of Convent Lane. This moved to Southcoates Lane in 1931. A convent in Park Grove was established by the Canonesses Regular of St Augustine, who arrived in Hull from Versailles after the declaration of anti-clerical legislation (known as the Combes Laws) in France in 1904. The convent of St Anthony in Beverley Road was set up in 1899 by the Sisters of Mercy. The Sisters of Charity of St Vincent de Paul had been in Hull since the 1870s, and they opened a boys' home in Queen's Road in 1909.

The Canonesses Regular of St Augustine started in Hull at Linden House in Pearson Park before moving into Park Grove via Willersley House. A Miss Hilda Hobson joined as

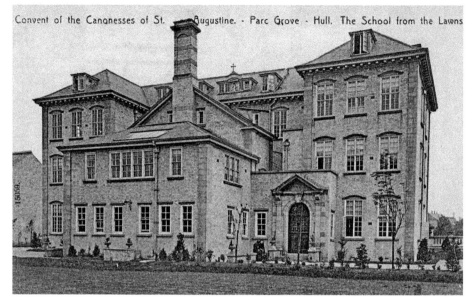

Convent of the Canonesses of St. Augustine. - Parc Grove - Hull. The School from the Lawns

The Park Grove school.

the first English postulant in 1906, took the name Mother Philomena as headmistress, and in 1920 became Mother Superior. She died in 1989 at the age of 101. The school closed in 1972. The original walls and entrance gates now make up the front gates of Convent Court and Sycamore Court on Park Grove.

12. Reckitt & Sons Ltd, 1840

The name Reckitt & Sons, of Dansom Lane, is probably less well known than some of its staple household products. These include Brasso and Nurofen and a variant of the chemical developed by Joseph Lister (after whom Listerine was named) in 1932 to make the famous medical profession-endorsed germicide we know as Dettol.

In 1840 Isaac Reckitt founded the firm that was to become Reckitt & Colman, a global leader in household, toiletry, food and pharmaceutical products. Starting with a mere twenty-five employees, the company now employs more than 25,000 people worldwide. Reckitt's first two business failed but it was lucky third time when in 1840 he bought a starch manufacturer, Middletons, in Dansom Lane. The highly successful washing blue and black lead for polishing were soon added to the portfolio. In 1938 the company merged with J&J Colman, world leaders in English mustard. Other household names – power brands – include Strepsils, the hair removal brand Veet, the air freshener Air Wick, Calgon, Clearasil, Cillit Bang, Durex, Lysol, Harpic, Mycil, Scholl's foot care products and Vanish.

The year 1999 saw the merger between Reckitt & Colman Plc and the Dutch company Benckiser NV. In 2014 Reckitt Benckiser moved its specialty pharmaceuticals business into a separate company called Indivior after changing its name to RB. Save the Children has described RB as its 'most valuable UK-based corporate supporter'.

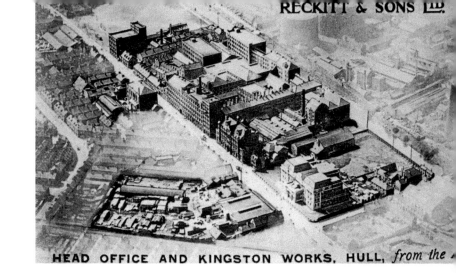

RECKITT & SONS L^{TD}.

HEAD OFFICE AND KINGSTON WORKS, HULL, *from the*

Reckitt from
the air.

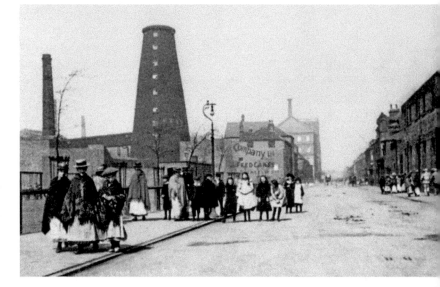

Reckitt girls
leaving work.
The Subscription
Mill is on the
left. When it was
demolished, the
Brasso building
was built on
the site.

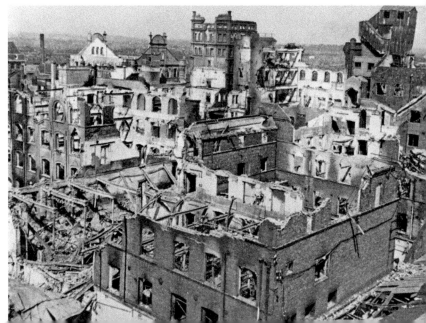

Bomb damage
at the Kingston
Works, 19 July
1941.

13. Paragon Station, 1847

Paragon Station and the adjacent Station Hotel, designed by railway architect G. T. Andrews, opened in 1848 to serve as the new Hull terminus for the growing traffic of the York & North Midland Railway (Y&NMR), leased to the Hull & Selby Railway (H&S). The station was also the terminus for the Hull to Scarborough line and from the 1860s the terminus of the Hull & Holderness and Hull & Hornsea railways. The station and hotel were both built in the Italian Renaissance style, with both Doric and Ionic elements – the facades were inspired by the interior courtyard of the Palazzo Farnese in Rome.

The name comes from the nearby Paragon Street, which was itself built around 1802, although the name is earlier still – from The Paragon Hotel public house (now the 'Hull Cheese'), which gave its name to the street and dates back to 1700. The station was opened as 'Hull Paragon Street' on 8 May 1848.

In the early 1900s the North Eastern Railway (NER) expanded the train shed and station, erecting the five-arched-span platform roof we see today. During the First World War, on 5 March 1916 a Zeppelin raid killed seventeen people when a bomb blast blew out the glass in the station roof. A bus station was built next door in the mid-1930s. The station took direct hits on the night of 7 May during the Hull Blitz of 1941. The signal box was badly damaged when a parachute mine exploded nearby and the small railway museum was destroyed by fire. In the early 2000s plans for an integrated bus and rail station were revealed: the new station, Paragon Interchange, opened in September 2007, integrating the city's railway and bus termini.

Paragon Station in the 1970s – note the distinctive white telephone boxes on the right.

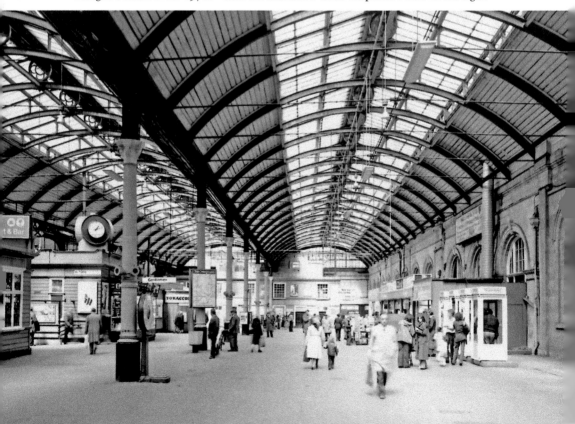

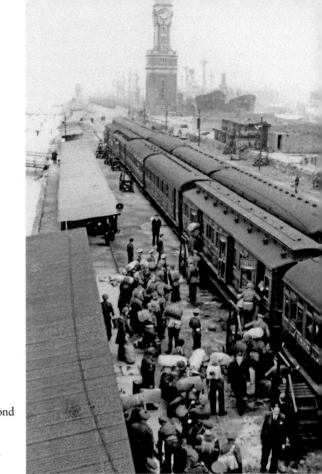

Right: Troops embarking during the Second World War.

Below: Paragon Station and the Boer War memorial.

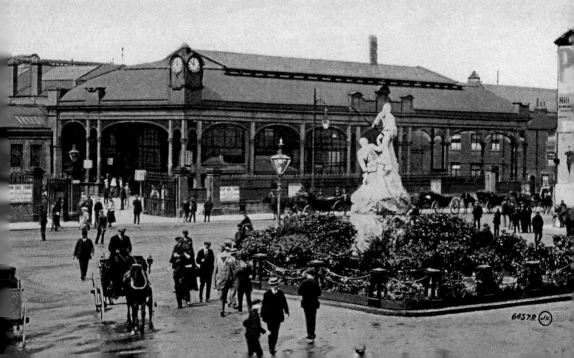

S.A. War Memorial and N.E. Rly. Station, Hull

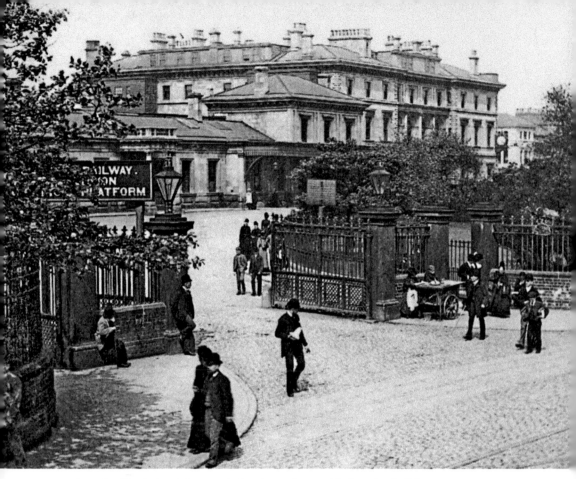

An unfamiliar isolated Paragon, before it was hemmed in by other buildings.

A £65,000 bronze statue of Philip Larkin by Martin Jennings was unveiled on the concourse of Hull Paragon Interchange on 2 December 2010, to mark the 25th anniversary of the poet's death. The statue is near to the entrance to the Station Hotel, a place often patronised by Larkin and immortalised by his 'Friday Night in the Royal Station Hotel'. The following year, five slate roundels featuring inscriptions of Larkin's poems were set in the floor around the statue, and in 2012 a memorial bench was installed near the statue. The hotel's official name is now the Mercure Hull Royal Hotel.

14. The Corn Exchange, 1856, and the Hull and East Riding Museum

What is now the Hull and East Riding Museum – the former Corn Exchange at No. 36 High Street – was originally a Customs House where customs and excise officers assessed cargoes for the payment of duties – Hull had a reputation for not paying custom and excise duties. Striking features of the building include the bearded mask over the arch, which is supported by impressive Corinthian columns. In 1923 the building opened as a museum of commerce and transport, eventually becoming the Hull and East Riding Museum in 1991.

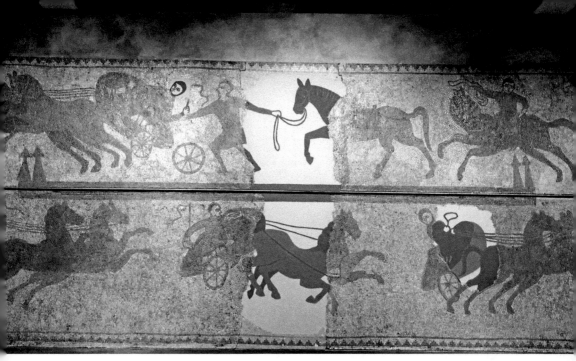

The Corn Exchange 1856, now the Hull and East Riding Museum. Two of its magnificent exhibits are the chariot race mosaic from Horkstow, North Lincolnshire – the only surviving chariot mosaic in Britain– and the reconstruction of a Roman bathhouse.

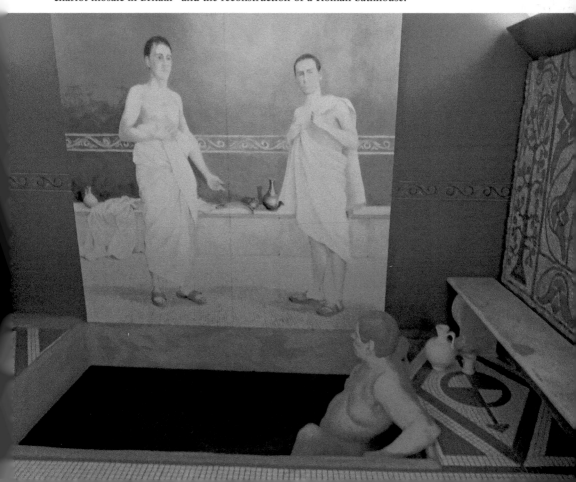

Museum highlights include a full-sized model of a Jurassic woolly mammoth; the strange Roos Carr figures, doll-like wooden sculptures from around 600 BC representing warriors or gods; the Celtic North Grimston Sword; a full-size reconstruction of an Iron Age settlement with thatched roundhouse and two-horse chariot; the 2,300-year-old Hasholme Boat, a huge oak logboat sank with its load of wood and beef; a recreation of the Roman settlement of Petuaria (Brough); silver coins minted in Frisia; a bronze Coptic bowl from Egypt; and a Viking sword found when a tenth-century bridge was excavated at Skerne, near Driffield, in 1982–83.

15. Pearson Park, 1860

Pearson Park lies between Princes Avenue and Beverley Road and it 'still resonates with Victorian grandeur'. Philip Larkin lived in a house, No. 32, overlooking Pearson Park from 1956 to 1974. Princes Avenue was once known as Mucky Peg Lane after the ankle-deep mud that had to be negotiated; however, there is a Mucky Peg Lane in York, which is reputedly named after a lady of ill repute...

Originally known as the People's Park, it was the first public park to be opened in Hull. The land was gifted by Zachariah Charles Pearson (1821–91) to mark his first term as Hull's mayor. Shrewdly, he retained around 12 acres of land on the periphery of the park to build some very desirable villas. Most have survived including No. 32, owned by the University of Hull. Two years later Pearson was undone after he bought, on credit, a fleet of ships to gun run through the Federal blockade during the American Civil War (1861–65). All his ships were captured. Pearson was ruined and spent the last twenty-nine years of his life reflecting on his folly in a modest terraced house in a corner of the park that bears his name. Features of Pearson Park include a serpentine lake, a carriage drive running around the perimeter, and a Victorian conservatory, which was rebuilt in 1930. In 1864 the park could boast a cricket ground, a folly called The Ruins, and statues of Queen Victoria and of Ceres, the goddess. Other areas were devoted to a bowling green and spaces for archery and gymnastics.

The main entrance to the park is at the end of Pearson Avenue on Beverley Road through an elaborate cast-iron gateway created around 1863. The gateway is now listed along

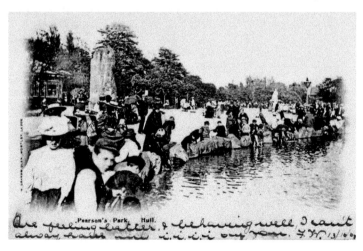

Pearson Park around 1903.

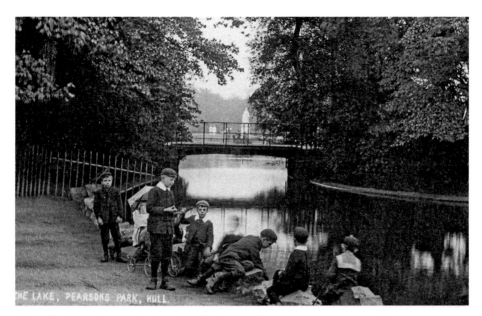

Edwardian boys in 1908 in the park. The iron bridge is gone.

Before there were parks in Hull there was the Zoological Gardens on Spring Bank. This early photo from 1854 shows the pheasantries and the menagerie building to the left.

with a number of other park features. They include the east entrance lodge (No. 1) built in 1860–61, an ornate cast-iron canopied drinking fountain erected in 1864, the statues of Queen Victoria by Thomas Earle in 1861 and of Prince Albert in 1868, the Pearson Memorial, an iron-stone monolith featuring a marble relief carving created in 1897, the cupola from Hull's town hall built in 1866 (erected here in 1912), and three of the surrounding villas (Nos 43, 50 and 54) built in the 1860s.

Before there were parks there was the 7-acre Zoological Gardens on Spring Bank – an important place of entertainment with pheasantries and a menagerie. In the summer there

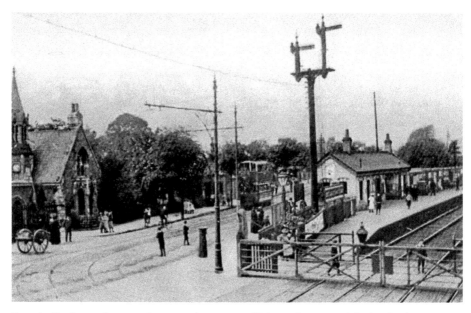

Botanic Gardens railway station near the corner of Princes Avenue and Spring Bank.

were weekly galas and typoramas of strange and exotic foreign cities. The gardens closed in 1854 and Peel Street and Hutt Street were built on the land.

Before that Hull Botanical Gardens were laid out in 1812 on a 6-acre site near what is now Linnaeus Street. In 1877 they moved to a 49-acre site in Spring Bank but closed in 1889 due to money problems. In 1893 the site was taken by Hymers College. The Hull Botanic Gardens railway station was here from 1853; it closed to passengers in 1964. The original name was Cemetery, changing to Cemetery Gates 9 in 1866, before Botanic Gardens in 1881. There is another botanical gardens in the grounds of Thwaite Hall, Cottingham.

16. Hull School of Art, 1861

Hull School of Art was founded in 1861. It has made a long and circuitous journey to its present place in Hull College with its present name, the Hull School of Art and Design.

In the early days classes were held in the Public Assembly Rooms, now the New Theatre. In 1878 the School of Art moved to a house on Albion Street. In 1901 it moved again, to Anlaby Road; the new building was completed in 1905. In 1930 this became Hull College of Arts and Crafts, then, in 1962, the Regional College of Art and Design. In 1972 a new art college building on Queens Gardens was commissioned, taking in its first students in 1974. The Hull School of Performance Arts is in the Horncastle building, the school which features a fully equipped TV studio, radio and newsroom, recording studios, and rehearsal spaces and the 200-seat Riverside Theatre.

The Northern Theatre Co. in Anlaby Road was established in 1975. The Northern Academy of Performing Arts has its origins in the theatre company and runs a multitude of courses including costume design, tai chi, street dance, stage combat and virtually every kind of dance, drama and musical theatre.

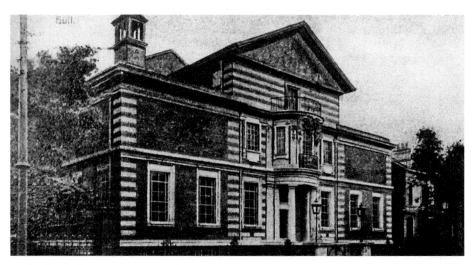

Hull School of Art in Anlaby Road.

17. Kingston Observatory, 1863, or B. Cooke & Sons

B. Cooke & Sons is a nautical instrument suppliers still thriving in Market Place after over 150 years of trading. The shop is teeming with clocks, sextants, barometers, globes and telescopes – new, second-hand and reconditioned. Some instruments, the heeling error for

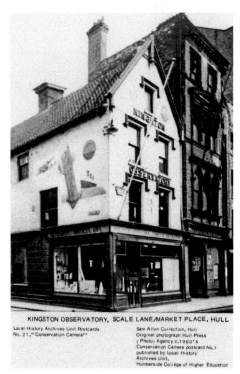

KINGSTON OBSERVATORY, SCALE LANE/MARKET PLACE, HULL

Local History Archives Unit Postcards
No. 21."Conservation Camera"·

Sam Allon Collection, Hull
Original photograph Hull Press
(Photo) Agency c.1960's
Conservation Camera postcard No.1
published by Local History
Archives Unit,
Humberside College of Higher Education

Kingston Observatory then B. Cooke & Sons.

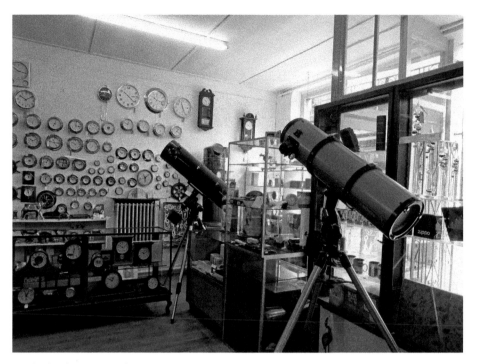

Inside the shop in March 2017.

example, an instrument that helps to adjust compasses, are unique to Cooke's. They are also official admiralty paper chart and paper book agents, as well as electronic chart and digital publications agents for all official admiralty products.

B. Cooke & Son Ltd was founded by Barnard Cooke, clockmaker and optician and the younger brother of Thomas Cooke of York, the world-renowned telescope and clockmaker.

In 1863 Barnard is recorded working as an optician at No. 56 Saville Street. In 1892 the business was at No. 44 Saville Street and by 1882 is described as opticians and sewing machine agent, adding, in 1882, chronometers and clockmakers to the portfolio. In 1918 B. Cooke & Son was sold to Henry Hughes & Son of London. The new manager, Stacy Dickeson, bought the company in 1926. The company is still owned by Mr Stacy Dickeson's daughters, Mrs Patricia MacPherson and Dean Yonge.

18. Jubilee Primitive Methodist Church (Spring Bank), 1864

Opened by the Primitives in 1864 on Spring Bank, the chapel was renovated in 1952 and replaced by a new building in 1959. It was then joined by Alexandra Street, Argyle Street and Fountain Road chapels. Nearby on Spring Bank was West Parade Chapel opened by the Wesleyans in 1874. It was replaced by Argyle Street in 1895 and used as a Sunday school until 1910. It later became a cinema and in 1964 a warehouse. Spring Bank was a mission room used by the primitives from 1888. It was demolished in 1964 and replaced by Jubilee Spring Bank. The name Spring Bank derives from the fact that Hull's water supply came into the city down here from Julian Springs via an open ditch.

Jubilee Primitive Methodist Church
(Spring Bank) being demolished
in 1964.

19. Sailors' Orphan Homes, 1867

This marvellous society was born in 1821 when a meeting was held in St Mary's Boy's schoolroom in Salthouse Lane, initially to help veterans of the Napoleonic Wars. The 'Port of Hull Society for the Religious Instruction to Seamen' was thus founded and a floating chapel, *Valiant*, opened for worship in the Humber Dock.

In 1837 the society started to reach out to families, particularly children. The Sailors' Orphan Institute was established in Waterhouse Lane for clothing and educating children of deceased seamen and rivermen. The year 1867 saw the first orphan house open in Castle Row. Next the society purchased Thanet House in Park Street to house 100 orphans. Titus Salt, of Saltaire fame, was a principal donor. Park Street was extended to accommodate 220 children but still proved inadequate to satisfy the demand, so, in 1892, the society bought 6 acres at Newland on Cottingham Road to erect purpose-built cottages. From 1895 up to twenty-five orphans lived in each of the ten cottages under the care of a house mother. A school, assembly and dining hall and sanatorium completed the model village. A swimming pool was added in 1921.

All the children shared in household chores while the girls were trained in household skills to prepare them for work in service. In 1908 the society opened a holiday and convalescent home in Hornsea. The year 1914 saw the influx of the first children of Royal Navy casualties raising the population to 360. In the Second World War the children were evacuated to Pateley Bridge and Brighouse, while the Newland Cottages were pressed into war service. The Women's Voluntary Service moved in, a nursery was set up for mothers

doing war service, Russian mariners stayed while their ships were being repaired, and bombed out families moved in and an emergency feeding centre was set up here.

The name was changed to the Sailors' Childrens' Society, which continues to assist the dependants of Royal and Merchant Navy personnel and fishermen's families at Francis Reckitt House in Newland.

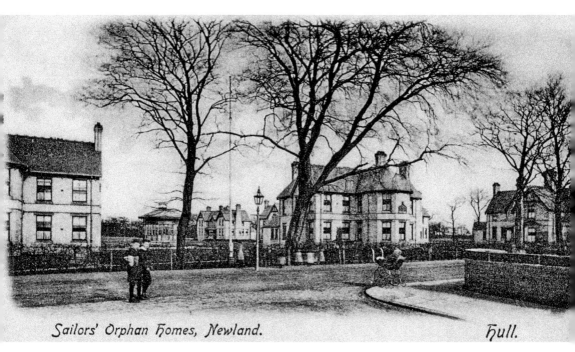

Sailors' Orphan Homes, Newland. *Hull.*

Above: Sailors' Orphan Homes, Cottingham Road, just down from Cranbrook Avenue.

Below: Orphans gardening.

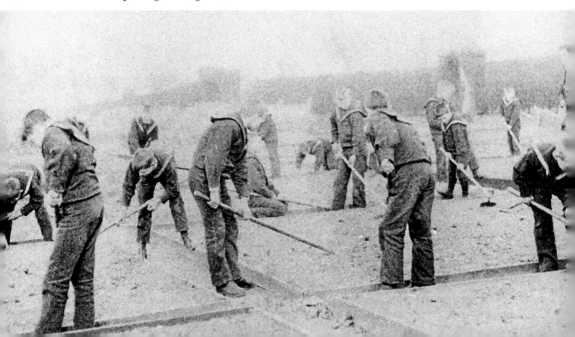

20. Hull Prison, 1870

Hull opened in 1870 to house men and women. In the Second World War it was a civil defence depot and military prison. In 1955 it was a borstal. The only woman to be hanged at Hull was Ethel Major of Kirby-on-Bain in Lincolnshire. She was convicted of poisoning her abusive and often drunk husband, forty-four-year-old lorry driver Arthur, with strychnine. Arthur Major made the mistake of demanding to know the identity of the father of Ethel's daughter, Auriel; Auriel was passed off as Ethel's sister.

The executed of Hull:

Arthur Richardson, thirty, on 25 March 1902. Murdered his aunt.

William James Bolton, forty-four, on 23 December 1902. Stabbed his former girlfriend to death.

Charles William Aston, nineteen, on 22 December 1903. Shot his former partner.

Thomas Siddle, twenty-nine, on 4 August 1908. Cut his twenty-two-year-old wife's throat.

John Freeman, forty-six, on 4 December 1909. Murdered his sister.

William George Smith, twenty-six, on 9 December 1904. Killed a woman he was 'on friendly terms with' in front of her three children.

Hubert Ernest Dalton, thirty-nine, on 10 June 1925. Murdered a colleague.

George Emanuel Michael, forty-nine, on 14 April 1932. Stabbed his partner several times in the head and throat, before attempting to kill himself.

Roy Gregory, twenty-eight, on 3 January 1933. Murdered his two-year-old stepdaughter. He struck her over the head with a hammer before hiding her body in the cellar behind a wall. Her body lay undiscovered for five months.

Ethel Lillie Major, forty-three, on 19 December 1934. Killed her husband by poisoning his corned beef with strychnine.

HM Prison Hull.

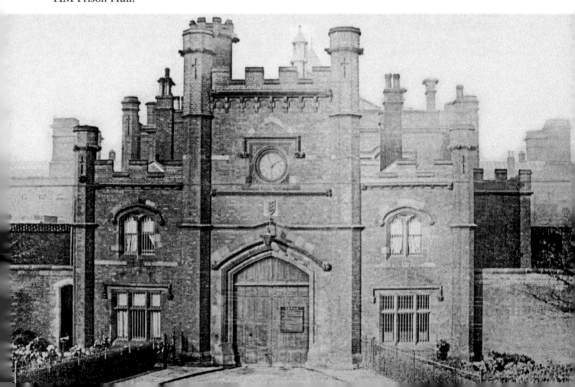

21. Hull Docks Office, 1871, and the Hull Maritime Museum

This impressive Italianate-style building in Victoria Square was originally the dock offices and the home of the Hull Dock Co., which monopolised the whole dock system until 1893. The building is aptly decorated with dolphins and other things maritime. The City Council purchased it in 1968 and it was converted for use by Hull Maritime Museum, which moved there in 1975 from Pickering Park. The museum was established in 1912 as the Museum of Fisheries and Shipping.

Highlights include a display depicting the oldest boat remains from the area, the Bronze Age craft from North Ferriby. A whole gallery focuses on Arctic whaling, which reached its zenith in the 1820s when Hull despatched sixty or more vessels to the Greenland Fishery every season; the gallery features contemporary paintings, ship models, relics, logbooks and journals. There is a skeleton of a whale surrounded by harpoons and other whaling paraphernalia. The museum also boasts the largest collection of scrimshaw – whaler folk art – in Europe. Scrimshaw is decorated whale jawbone, whalebone (baleen) and sperm whale teeth.

What was the Docks
Office is now...

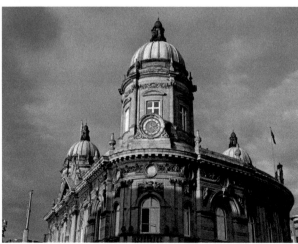

...the Maritime Museum.

22. Fish Dock, 1883

Fish and fishing had become so important to Hull's economy by the 1880s that a new dock that had been earmarked for coal was repurposed as a fish dock – St Andrew's Dock, named after the patron saint of fishermen. It extended more than 10 acres with room for stores, factories and offices for the fish trade, as well as for mast and block makers, iron founders, blacksmiths and shipwrights. In 1895 work started on extending the dock; the new facility opened in 1897. St Andrew's Dock was naturally the focus for smoke houses for making kippers. The 'cod farm' was the place where prodigious amounts of cod were split, salted, dried and exported.

Hull Fish Quay was implicated in an international incident involving Hull trawlers and the Russian Baltic fleet on 21 October 1904. This became known as the Dogger Bank Incident or, more graphically, the Russian Outrage. Mistaking Hull trawlers for enemy Japanese boats, Russian warships opened fire on the fishermen, killing a Hull skipper and a third hand and seriously wounding seven others. The trawler *Crane* was sunk. The hospital mission ship *Joseph & Sarah Miles* went to assist. Returning to St Andrew's Dock, vessels showed clear evidence of the damage caused. Protests to the Russian government predictably fell on deaf ears. A relief fund was set up and on 30 August 1906 a fine memorial was unveiled outside St Barnabas's Church in Hessle Road.

On 25 August 1929 the No. 2 market went up in flames, the fire fuelled by its wooden construction over its 468 yards length. It caused major damage to buildings and seven trawlers. Over the years the extensive facilities have included an ice plant, several banks, a doctor's surgery, a post office, cafés and a police station with cells.

Up to 350 fish vans would leave the dock every day by rail. During the Second World War, Hull trawlers acted as minesweepers and convoy escorts.

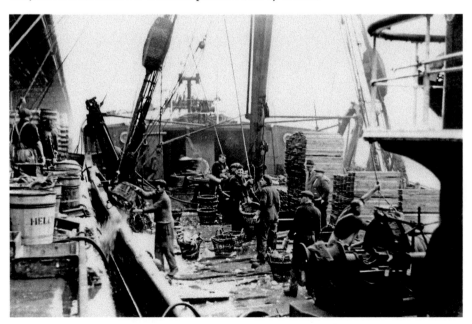

Fish dock workers unloading a trawler.

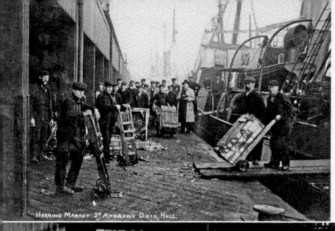

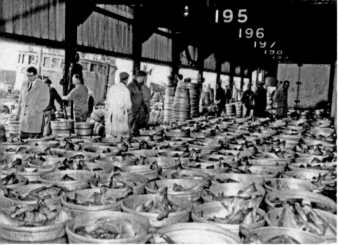

Left: More work at the fish dock – preparing fish for the fish trains.

Below: Kits of fresh fish at the Iceland Market in 1959 filled by 'gippers' – the men who replaced the fisher girls.

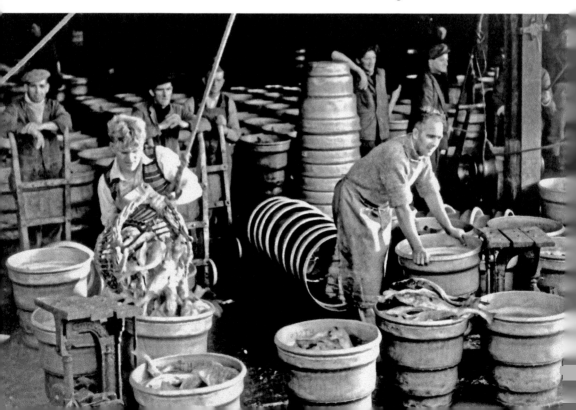

Crew often had less than sixty hours ashore before heading back out to sea. Goodbyes were said at home as it was considered bad luck for family – and in particular women – to go anywhere near the fish dock. St Andrew's Dock closed on 3 November 1975.

23. Needlers, 1886

Needlers can trace its history back to 1886, when a young man by the name of Frederick Needler of Skirlaugh started the sweet company. With a factory in Spring Street, he grew the company to the point where it produced 650 tonnes of chocolate and 1,500 tonnes of sweets in a year, but when the 1930s depression hit, the company floundered. Needlers needed a new way to compete against the other confectionery giants it was up against, such as Cadbury and Rowntree, and in 1938 it found one. Food chemists at Needlers discovered a way of producing clear fruit drops and sales shot up dramatically. The company stayed in business until 2002 when it was acquired by Ashbury Confectionery.

In 1900 Needler was employing ten female and twenty-three male workers producing a variety of lines: thirty-eight different boiled sweets, forty types of toffees, thirty-five health sweets, fourteen pralines and fifteen different labelled sticks of rock.

The company was also wholesaler for other firms, such as the German Quaker company Stollwerk, Cadbury's, Fry's, Craven's, Taverner's and Rowntree's. This ended in 1912 when the product range was 576 lines of which seventy-four were chocolate. In 1906 a new five-storey chocolate plant was built in Lotus Avenue off Bournemouth Street to cater for this.

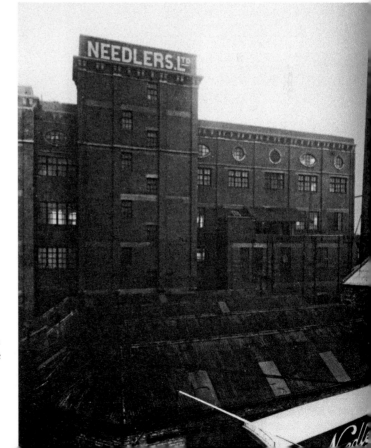

In 1906 a new five-storey chocolate plant was built in Lotus Avenue off Bournemouth Street to cater for the chocolate side of the business.

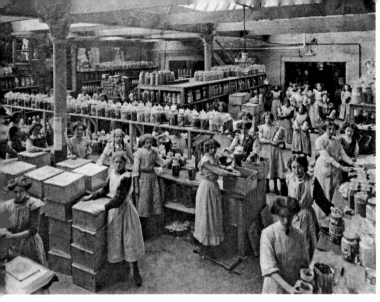

Packing jars at Needlers around 1910.

A horse-drawn Needler van proceeds up Spring Bank in 1905 – note the telephone number '90X' and the poster outside Coult's Newsagents announcing 'Japan's advance in Manchuria' during the 1904–05 Russo-Japanese War.

By 1920 the turnover was £570,000, comprising 650 tons of chocolate and 1,500 tons of sweets, with a range now including Christmas boxes and Easter eggs. There were 1,700 employees, mostly women. In 1929 the catalogue featured twelve different assortment boxes and numerous chocolate bars. The boxes gloried in such names as Wilberforce, Minaret, Lido, Eldora, Carlton and Crown Derby. Kreema milk chocolate was advertised as being 'Creamy! Velvety! Delicious!' The 1939 catalogue shows some innovative packaging for Christmas with attractive receptacles, practical and ornamental.

Sales were boosted when green sweet jars were replaced by clear glass. Air conditioning was installed in the factory in 1927, permitting all-weather packing. Wrappers had been introduced in the early 1920s and wrapping was automated in 1928. Up to 1918 goods were shipped either by horse-drawn vans or crated and sent by rail. A fleet of vans was built up and by 1927 there were forty delivery vans, all smartly liveried in chocolate brown. Rail distribution was terminated in 1950 when British Rail introduced hump shunting, which resulted in unacceptable levels of jar breakages. The firm's exhibition vans were requisitioned in 1939 and never seen again.

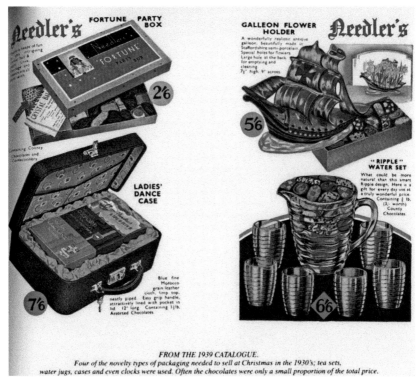

A selection from the 1939 trade catalogue – sweets in the minority.

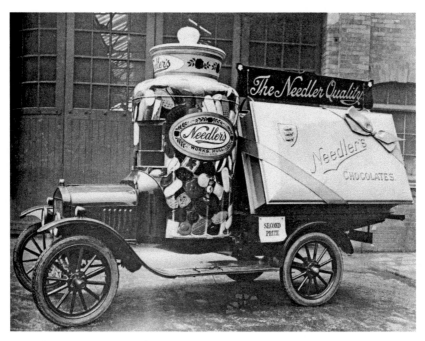

A Ford AT 5624 decorated for second prize in 1920.

Needlers innovative chemists perfected clear fruit drops – Glace Fruit Drops – in 1938, resulting in another lift in sales. In 1938 production moved away from chocolate due to pressure from the likes of Cadbury, Rowntree and Mars. Post-war demand for Glace Fruit Drops exceeded supply until 1957.

Frederick Needler was a close friend of Tom Ferens of Reckitt's (also a Methodist), who was involved in the founding of University College, later the University of Hull. Needler personally bought and then gifted Needler Hall in Cottingham to the college as a men's hall of residence.

Hillsdown holdings bought Needlers in 1986 along with Bluebird Toffee of Birmingham. Nora AS, Norway's biggest food group, bought the company in 1988, although sweets continued to be produced in Hull under the Needler brand name. Amazingly, all the catalogues were photographed in black and white and then skilfully coloured in by hand using water colours. These colour pictures were then converted into three colour separations and printed up in house.

24. The Andrew Marvell Statue, 1886

Everyone associates Philip Larkin with Hull but Andrew Marvell (1621–78) was Hull's first celebrated poet. Penning poetry apart, from 1659 until his death in 1678 Marvell served as London agent for the Hull Trinity House. His statue is a constant reminder of this, a statue which must be one of the most itinerant in the land. Marvell originally stood inside the old Town Hall in Alfred Gelder Street in 1886. When the old Town Hall was demolished to make way for the current Guildhall in 1902, Marvell went outdoors to the

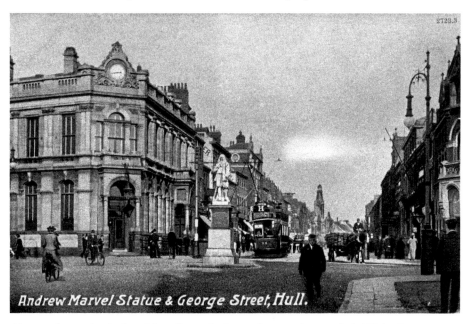

Above and opposite: Andrew Marvell once in George Street and currently in Trinity Square.

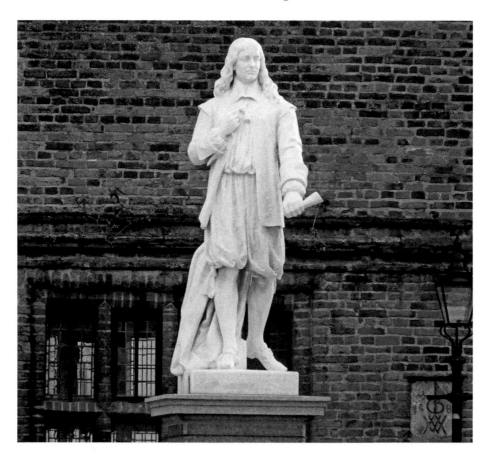

junction of George Street and Jameson Street. By 1922 traffic was shaking his foundations, so he moved to nearby Bond Street. He survived the blitz, but in 1963 the poet decamped to the main entrance to Hull Grammar School in Bishop Alcock Road. Marvell had been a pupil at the original grammar school in Trinity Square. Fittingly, he came back to the city centre and took up a position in 1999 in Trinity Square to mark Hull's 700th anniversary celebrations. In early 2016 he moved again a short distance within the square.

25. The Hull Brewery Co. Ltd, 1888

Hull Brewery went the way of many other independents when in 1971 it was taken over by Northern Foods and then bought by Mansfield Brewery in 1985. Before that, however, from 1887 Hull Brewery expanded at its Sylvester Street brewery, acquiring other brewers and bottlers, and purchasing licensed houses. By 1890 they owned 160 licensed houses. In 1925 it acquired the Lincolnshire brewery Sutton, Bean & Co. with beer shipped across the Humber by barge. Northern Foods took on 212 tied houses and changed the name to North Country Breweries Ltd in 1974. Mansfield Brewery called time on brewing at Sylvester Street in 1985.

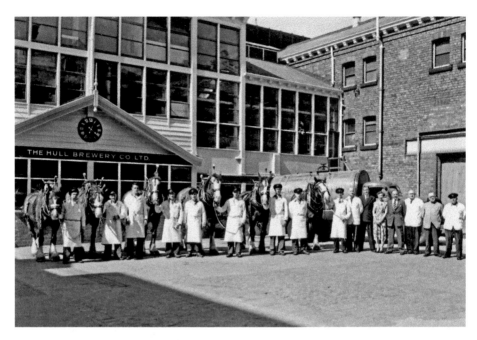

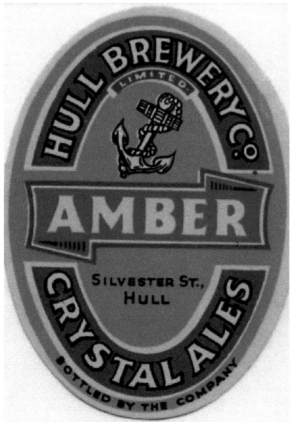

Above: Staff of the Hull Brewery Co. Ltd outside their building in 1957. Note the horses ready to haul the tanker.

Left: Hull Brewery's Crystal Ales.

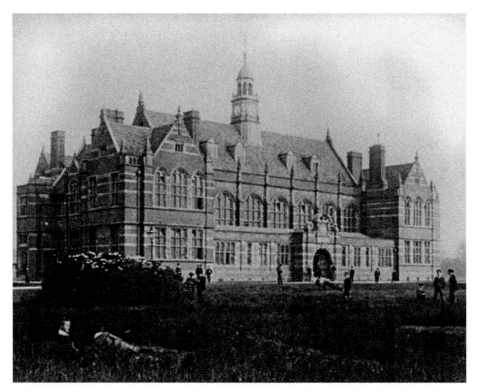

Hymers College.

26. Hymers College, 1893

The school is named after Revd John Hymers, mathematician, Fellow of St John's College, Cambridge, and rector of Brandesburton, who bequeathed money for a school 'for the training of intelligence in whatever social rank of life it may be found among the vast and varied population of the town and port of Hull'. It was duly built as a boys' school on the site of the Botanic Gardens. Right from the start, scholarships and bursaries were available to admit pupils whose parents could not afford the fees. In 1997 when the government-funded Assisted Places were abolished, the Governors decided that bursaries would be provided from the school's own resources so that the philanthropic wishes of its founder could be continued. The school has been fully co-educational since 1989 with around 1,000 pupils.

27. Public Toilets, Nelson Street, 1902

Among the best public toilets in Hull with a reputation extending back to 1902, these award-winning public lavatories are, according to the *Hull Daily Mail*, 'hailed as a shrine to sanitation, with generous displays of potted plants, gleaming cream tiles and polished brass, this is a fine place to 'spend a penny'.

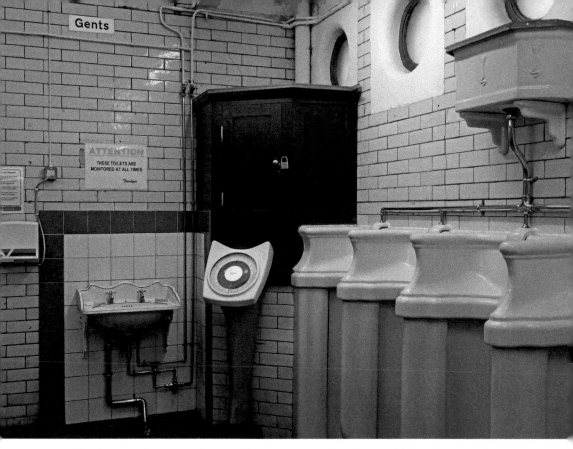

The elegant and pristine toilets in Nelson Street – Lord Nelson would have been proud.

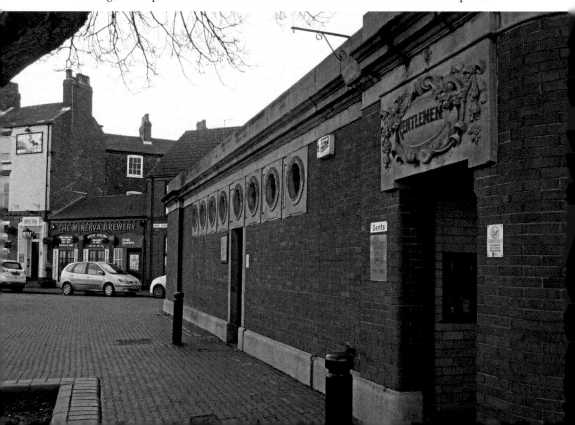

28. The Queen Victoria Statue, 1903

The larger-than-life 35-foot statue, like the 1923 subterranean municipal toilets beneath, is listed. The queen nearly avoided the lavatories and would have done so if the Queen's Memorial Committee had got its way. The minutes of the committee tell us: '22.02.1923

Queen Victoria fighting with the Blade in January 2017.

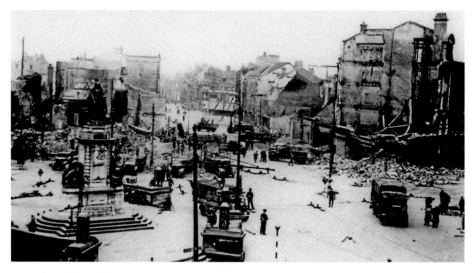

Second World War bomb damage around Queen Victoria.

Queen Victoria Statue, City Square: - ... resolution passed that the statue of Queen Victoria taken down in the City Square be not erected over the new public lavatory.' However, later minutes reveal that she had been re-erected in the square – over the toilets – by January 1924. The Prudential Buildings were destroyed on 7 May 1941 when high explosives hit the building, killing fifteen people sheltering in the basement.

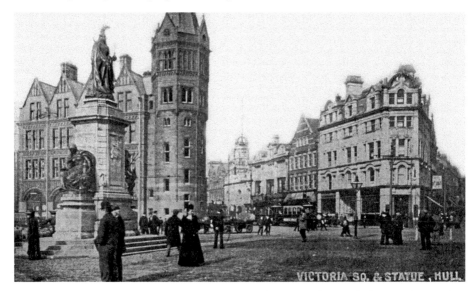

Edwardian Victoria Square with the prominent Prudential Buildings, which were destroyed in the Second World War.

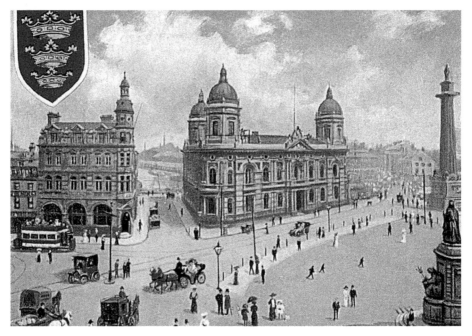

1920s Victoria Square in glorious colour with all manner of vehicular traffic.

29. Hull Telephone Boxes, 1904

Until 2007 Hull was the only city in the UK to have maintained an independent municipal telephone network provider operating under the name of Hull Telephone Department – now it is privatised as KCOM, once known as Kingston Communications, founded in 1902. KCOM have retained 125 or so K6s, which are still in use today. The company allocated approximately 1,000 for sale to the public. So, in Hull you will see distinctive cream phone boxes not red ones, and its residents get the White Pages telephone directory, and 'Colour Pages' for business numbers, as opposed to the 'Yellow Pages'. Golden Pages (a forerunner to Yellow Pages) was first published in Hull in 1954 to celebrate Hull Telephone Department's golden jubilee. In January 2017 it was announced that KCOM were installing a number of classic cream-coloured K6 telephone boxes in the city centre including Whitefriargate and Jameson Street as part of Hull's City of Culture celebrations.

The K6, made of cast iron, was designed by Sir Giles Gilbert Scott (1880–1960), who was also responsible for designing Battersea Power Station and Liverpool's Anglican Cathedral. Giles' father, George Gilbert Scott Jr (1839–97), designed the Victorian villas on Hull's Salisbury Street. Unlike the red version, Hull's boxes do not feature the imperial crown. In 2012 a K6 in Market Place was painted gold to honour Hull Olympic medallist Luke Campbell. Several K6 kiosks in Hull are now officially listed as historic buildings of architectural importance. In 2006 the K2 telephone box, either version, was voted one of Britain's top-10 design icons, which included Concorde, Mini, Supermarine Spitfire, the London tube map, World Wide Web and the AEC Routemaster bus. The distinctive cream telephone boxes are highly symbolic locally, communicating to visitors the proud independence that characterises the city and its citizens.

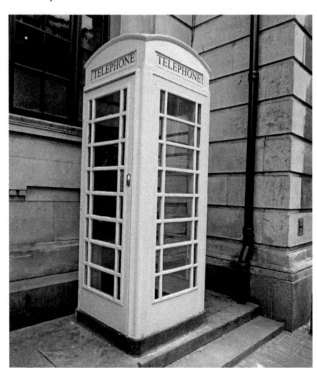

A quintessentially Hull cream telephone box; this one is in Alfred Gelder Street.

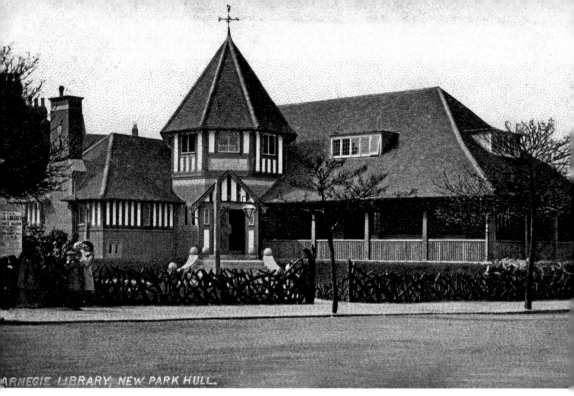

ARNEGIE LIBRARY, NEW PARK HULL.

The Carnegie Free Library.

30. The Carnegie Free Library, 1905

Now known as the Carnegie Heritage Centre, the Carnegie Free Library opened in 1905 and became Hull's fifth branch library. It was financed by the Scottish-American industrialist and philanthropist Andrew Carnegie and was one of the 3,000 Carnegie libraries he set up in the UK and USA and countries in what was then the British Empire. The first in the UK was opened in 1883 in his home town of Dunfermline. The deal was that Carnegie would build and equip them, but only on condition that the local authority matched that cost by providing the land and a budget for operation and maintenance. Typically they comprised comprised a lending library, reference library and newspaper reading room.

Hull's Carnegie can be found at the gates of West Park and is unusual among Carnegie libraries because of its half-timbered construction. It served as a public library until 2001 when library services moved to a learning centre at the KC Stadium next door. The Carnegie Heritage Action Team was formed in 2006 to save the building and create a centre for local and family history resources. This centre opened in August 2008 and took in material from the local history collections of Hull College. The East Yorkshire Family History Society works from there.

31. The Guildhall, 1907

The history of the Guildhall with its magnificent sweep along Alfred Gelder Street begins with the Town Hall designed by Cuthbert Brodrick (of Leeds Town Hall fame) and opened in 1866 at the north end of Lowgate. Soon after Hull was granted city status in 1897,

a larger building was needed so land to the west of the Town Hall was acquired for the present Guildhall, which opened with law courts, a council chamber and offices in 1907. The Town Hall was demolished in 1912 and the east end of the Guildhall building was built between 1913 and 1916 in the Renaissance style. The Guildhall has a plethora of treasures that include fine art, sculpture, furniture and the civic insignia and silver. It boasts miles of oak and walnut panelling, marble floors and Hull's old courts and cells. The Hull Tapestry is also in the Guildhall. The cupola from the ornate 135-foot tower on the Town Hall was recycled to beautify the west end of Pearson Park.

The statuary on the Guildhall is quite stunning: the photo shows maritime prowess with the Greek goddess Aphrodite rising from the waves between two horses.

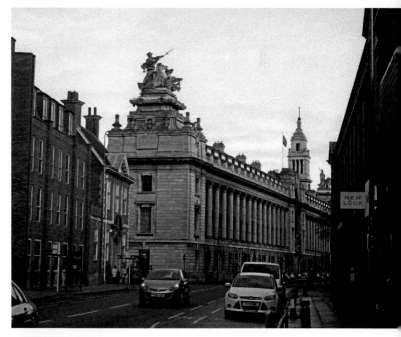

The Guildhall.

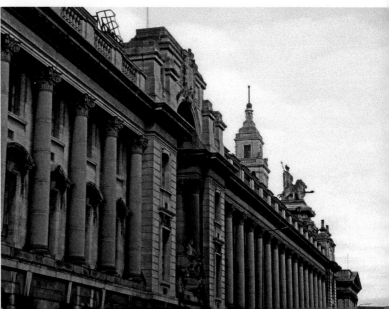

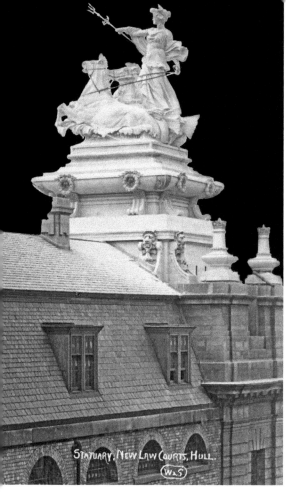

STATUARY, NEW LAW COURTS, HULL.

Left: Maritime prowess with the Greek goddess Aphrodite rising from the waves between two horses.

Below: The short-lived Town Hall.

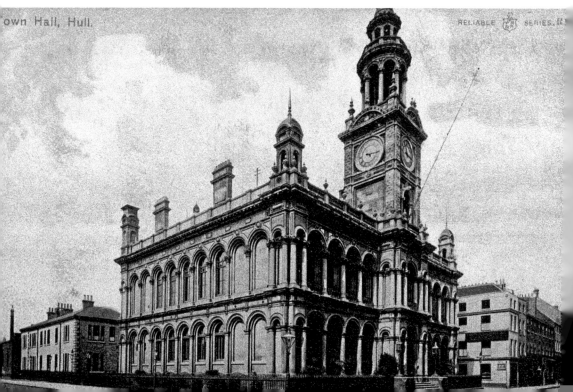

own Hall, Hull.

RELIABLE SERIES.

32. The Reckitt Model Village, 1908

The deeds for the village are dated 23 December 1907. The Garden Village was the realisation of Quaker Sir James Reckitt's wish to improve the domestic and social circumstances of the workers at his household products, disinfectants and pharmaceuticals factory in Dansom Lane. The company originates from 1840 when Isaac Reckitt rented, and eight years later, bought a starch mill and then diversified into staple household products such as washing blue and black lead for polishing.

Sir James summed up his vision in February 1907 when he wrote to the general manager, later director, T. R. Ferens MP:

> Whilst I and my family are living in beautiful houses, surrounded by lovely gardens and fine scenery, the workpeople we employ are, many of them, living in squalor, and all of them without gardens in narrow streets and alleys ... the time has come ... to establish a Garden Village, within a reasonable distance of our Works, so that those who are wishful might have the opportunity of living in a better house, with a garden, for the same rent that they now pay for a house in Hull with the advantages of fresher air, and such Clubs, and outdoor amusements, as are usually found in rural surroundings. The outlay would gradually be very large, but some revenue would be derived from rents.

James Reckitt reiterated the beneficial effects of gardens in his speech at the opening of the village: 'The objects of this Garden Village are to provide a House and a good Garden, in fact a better house if possible, and a garden attached for the same rent as is now paid for inferior houses with no garden at all'. Sir James Reckitt put £150,000 of his own money into it.'

The estate comprises around 600 houses on 130 acres with a population of just over 3,000. That the vision was considered realised is evidenced by this effusive statement in

The Reckitt Garden Village. At the centenary celebrations on 27 July 2008, residents dressed up in Edwardian costume to lend an air of realism to the event.

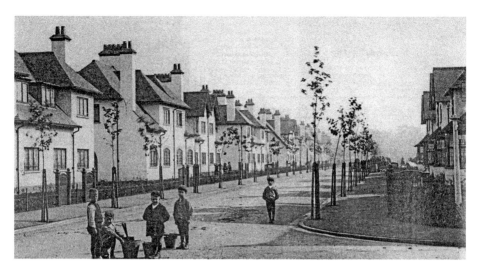

Each house had a cut behind the houses and gardens so that manure carts (and buckets) could reach the gardens for fertilization.

the Foreword of the Garden Village Horticultural Society August 1911 Show Programme: 'Whilst not far from the main road, the Garden Village is sufficiently rural and secluded to bestow on its inhabitants all the benefits of rus in urbe' countryside in the city. One of the original requirements was that every house should have a rear garden and privet hedge between 2 feet 6 inches and 4 feet high separating the houses at the front.

Reckitt Hall, one of the University of Hull halls of residence at The Lawns in Cottingham is another example of 'rus in urbe'. At the centenary celebrations on 27 July 2008, residents dressed up in Edwardian costume to lend an air of realism to the event.

There were first-class houses for Reckitt's senior staff and second-class houses for the workers. Tenants could choose the colour of the distemper for their walls and dictate the route of the garden path; the Garden Village Co. built greenhouses, summer houses or garden sheds at their own expense.

To avoid overcrowding, there was a maximum of twelve houses per acre of land and each house took up 500 yards of land – estimated as worth 2*s* in garden produce to the tenant. Thomas Ferens offered three 10-guinea prizes a year for the best gardens, emphasising how the garden village would boost the physical and moral development of its children. Each house had a cut behind the houses and gardens to so that manure carts (and buckets – see picture) could reach the gardens for fertilization. Tennis, bowls and croquet were available on the Oval for a charge and Ferens donated the boating lake in East Park.

First-class houses came with a bathroom and both an outdoor and an upstairs toilet while the second-class houses had the bath in the scullery under a lift-up tabletop and one outdoor toilet. All houses had a black stove in the kitchen, which heated the oven and the hot water. They had gas lighting and some houses had a telephone connected. The first-class houses had brass doorknobs; there was a bell at the front and back doors and in the main rooms so that when someone rang the bell, the room they were in was indicated on a panel in the kitchen.

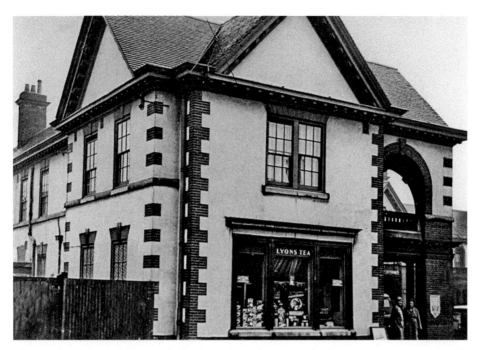

The Garden Shopping Centre. The back window of Hammonds department store is on the left with Peter Partington's butchers shop on the right, with discrete advertisements for 'Ox Beef' and 'English Hams' in the window.

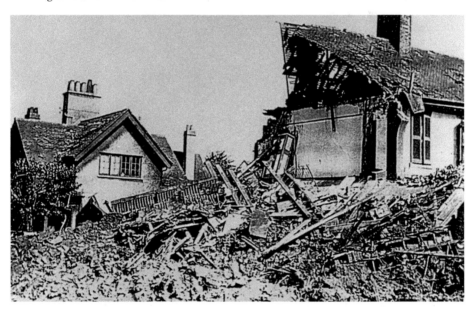

Thirty-one-year-old Eddie Morton was in bed as usual above his grocer's shop on the night of 18 August 1941 when an air raid started; a bomb exploded on his shop blowing him into Beech Avenue, the next street, while still in his bed.

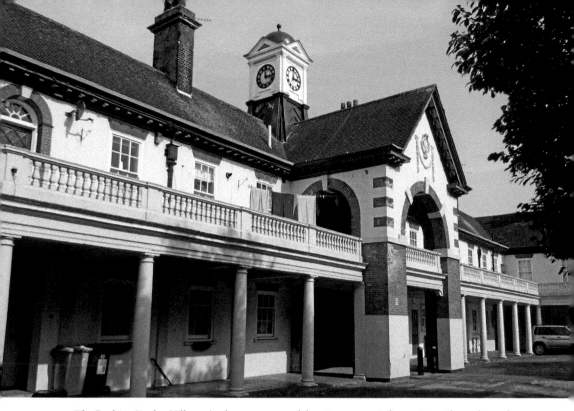

The Reckitt Garden Village. At the centenary celebrations on 27 July 2008, residents dressed up in Edwardian costume to lend an air of realism to the event.

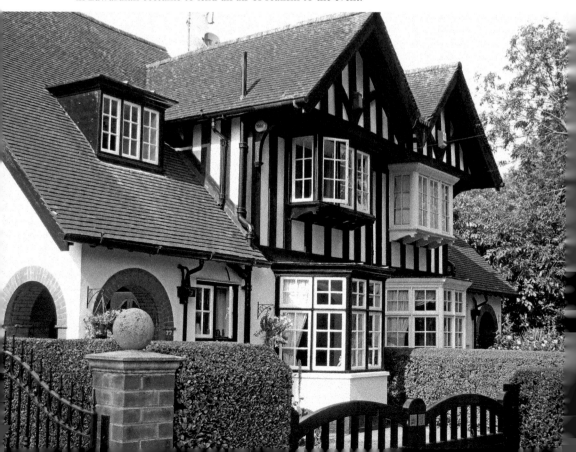

The fine Village Hall was destroyed by bombs in the Second World War but never rebuilt. Eight almshouses – the gift of George Reckitt's daughter, Juliet Reckitt – were provided rent-free to the occupiers. Twelve similar homes were gifted by Frederic I. Reckitt, the Frederic Reckitt Havens on Laburnum Avenue and a further twelve, the Sir James Reckitt Village Havens on Village Road. Occupants received a small weekly allowance and a bag of coal.

Thirty-one-year-old Eddie Morton was in bed as usual above his grocer's shop on the night of 18 August 1941 when another air raid started; a bomb exploded on his shop blowing him into Beech Avenue, still in his bed.

33. Hull City Hall, 1909

Built in Baroque Revival style, Hull City Hall was part of Hull Corporation's 'Junction Street' scheme in 1900, designed to form a central square in the city, to be known as Queen Victoria Square. The proposed City Hall was to include a main hall and three reception halls on the first floor, with the main entrance looking out onto the square.

This main hall was to have side and rear galleries and an orchestra, holding up to 3,000 people. In 1905 an art gallery in one of the smaller halls was proposed on the first floor. Accordingly, the Victoria Art Gallery opened in 1910 and survived until 1927 when a new building was opened, later known as Ferens Art Gallery. The Victoria Art Gallery remained empty until 1929 when it became an exhibition room for prehistoric antiques and in 1931 took the name Mortimer Suite. It was restored in 1950 after being wrecked in the war – with extensive damage to the roof, main hall, and the organ. it was altered further in 1986 and 1989. It is now a regular venue for pop, rock and classical music concerts.

Hull City Hall obscured by the Blade in March 2017.

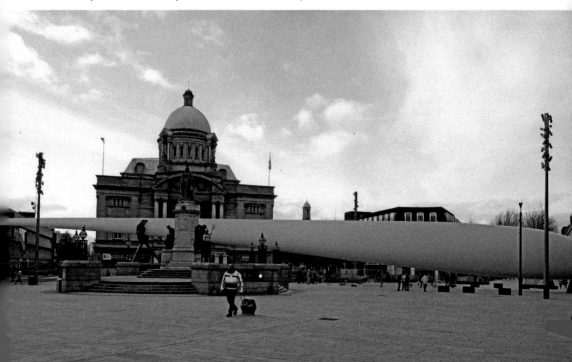

34. The Ferens Art Gallery, 1927

The site and construction of this major provincial gallery was donated by Thomas Ferens. It opened in 1927, was restored and extended in 1990 and reopened in January 2017 after a major £4.5-million refurbishment to prepare it to host the Turner Prize in 2017 as part of the UK City of Culture programme. Gallery highlights include masterpieces by Lorenzetti, *Christ Between Saint Paul and Saint Peter* (1320) costing £1.6 million; Frans Hals, *Portrait of a Young Woman* (1660s); Francesco Guardi's *Sophronia Asking the Saracen King Aladine to Release the Christian Prisoners* (c. 1745); Antonio Canaletto, *The Grand Canal, Venice* (c. 1724); Frederick Leighton, *Farewell* (1893) and *Electra at the Tomb of*

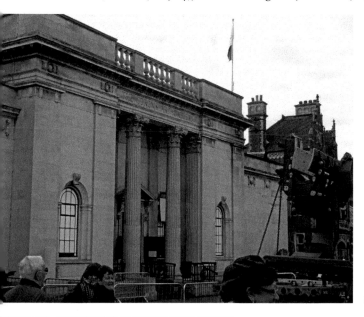

The Ferens Art Gallery, reopened after refurbishment in 2017.

Cindy in acrylic by Saskia Berkin, one of the exhibits at the Open Exhibition in the newly refurbished Ferens Art Gallery, March 2017.

Agamemnon (*c.* 1869); John Atkinson Grimshaw's *Princes Dock, Hull*; Walter Sickert's *Hotel Royal, Dieppe* (1899); Herbert Draper's *Ulysses and the Sirens* (1909); and works by Stanley Spencer, David Hockney, Helen Chadwick and Gillian Wearing.

35. University College/University of Hull, 1927/1954

University College Hull was founded in 1927 with the help of local benefactors including Thomas Ferens, who gave the land and donated £250,000, G. F. Grant and the City Council. The college opened with thirty-nine students and fourteen 'one-man' departments. By 1931 there were 100 students sharing one building – now called the Venn Building. University College Hull was affiliated to the University of London and offered courses in the arts and pure sciences. The college won its independence in 1954 when the University of Hull became a separate institution with the right to award its own degrees – it was Yorkshire's third university and England's fourteenth. In 1956 the student population topped 1,000 for the first time.

In 1979 the School of Chemistry received the Queen's Award for Industry in recognition of Professor George Gray's work in the development of liquid crystals, which, of course, now have applications in everything from scientific equipment to LCD displays on mobile phones. In 1973 he published a paper proving that liquid crystals could be stored at room temperature, which opened the gates for all future advancements in the screens. Sadly, Professor Gray omitted to patent his work.

In 2000 the university merged with University College Scarborough; the college was originally a teacher training college and functioned as the University of Hull's Scarborough campus. In 2003 the University of Lincoln's Hull campus next door on Cottingham Road was acquired, increasing the size of the Hull campus by more than a third. The site now houses the prestigious Hull York Medical School.

Mike Stock (of Stock, Aitken & Waterman), Beirut hostage John McCarthy, Jill Morell – his lifeline and champion back in London and founder of 'Friends of John McCarthy' (FOJM) – musicians Tracey Thorn and Ben Watt (Everything But The Girl), film director Anthony Minghella, poet Roger McGough, actress Sally Lindsay (Coronation Street), TV presenter Sarah Greene (*Blue Peter*, *Going Live*), Labour politicians John Prescott, Frank Field, and Roy Hattersley, Jenni Murray of *Woman's Hour*, and Radio 1 presenter Mark Chapman all graduated from Hull University.

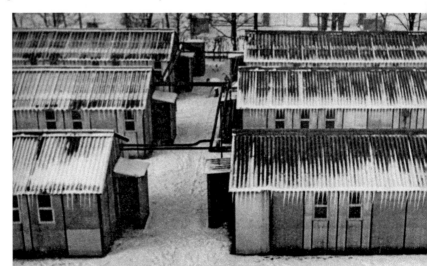

Post-war temporary huts at University College. These remained in use until the Brynmor Jones Library was completed in the 1960s.

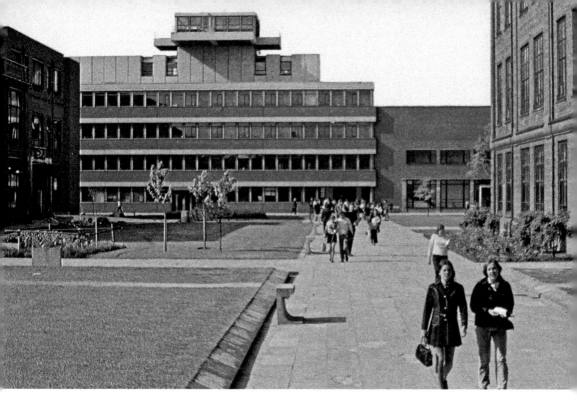

Above: The 'Main Walk' at Hull University in the 1970s.

Below: University of Hull Union building, 1 August 2012. (©Pjbeef under Creative Commons)

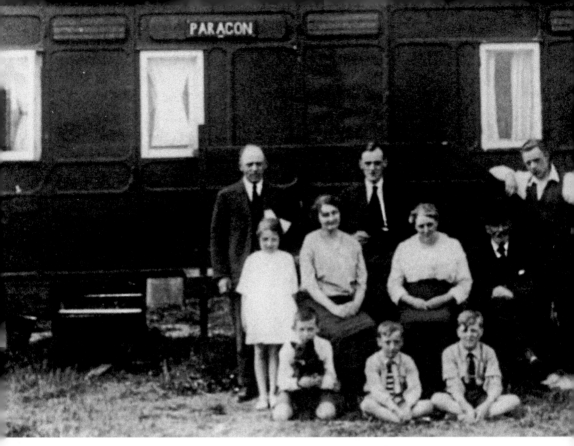

'Paragon Holiday Homes'.

36. 'Paragon Holiday Homes', 1930s

A truly innovative way to provide holiday accommodation for just about managing families. These old LNER railway coaches were converted into chalets and sited behind St Stephen's Church. Others were shunted into quiet railway sidings or redundant stations.

37. Hull New Theatre, 1939

Hull New Theatre was the realisation of one man's dream – Peppino Santangelo. He wanted to create a tradition of 'playing for the people' in Hull. It all started in 1924 with the ailing Hull Repertory Co. who performed in the Little Theatre, a converted lecture theatre on the site of the central fire station. The company hired Santangelo, an experienced rep pioneer, to save it. And save it he did: by 1939 the company had cleared its debts and made a profit of £4,364. Santangelo had his eyes on the Assembly Rooms (built in 1834) next door as a new home for the company. Despite the inconvenience of a war starting, Santangelo's irrepressible energy and determination got him his building.

Hull New Theatre opened in a fanfare of publicity in 1939. The opening performance was Noel Gay's *Me and My Girl*. Ever since it has lived under the threat of extinction, first from the Luftwaffe when it took a direct hit and then the even worse nightmare of turning into a bingo hall. To mitigate the first threat, the theatre bar was reinforced and made into

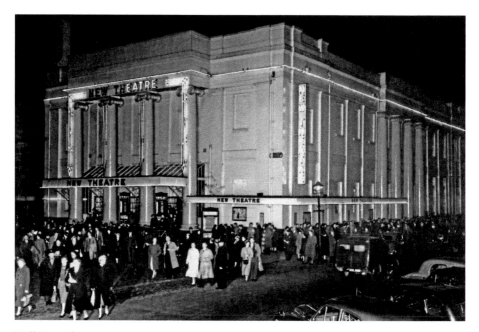

Hull New Theatre, 1954.

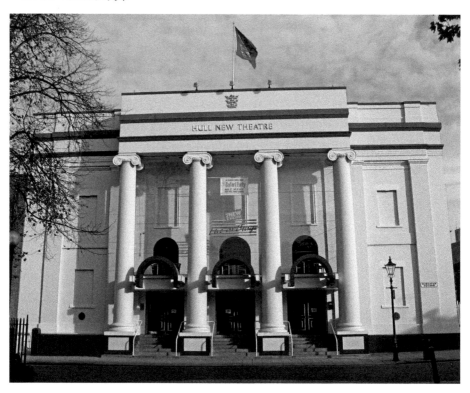

Hull New Theatre shot in 2006. (© Keith D. under Creative Commons)

a bomb shelter. On the night of May 7/8, however, the scenic studios were hit, demolishing the stage lantern, two auditorium doors, the front row of the stalls and all the props and costumes of the Sadler's Wells Opera Co.

The second threat was just as pernicious. In the 1960s Hull City Council came to the rescue and dispelled the bingo threat by forming the Kingston upon Hull Theatre Co. to run the theatre. Throughout the decade it went on to attract audiences of around 150,000 people each year. In 1985 the New Theatre, Hull, was refurbished extensively and reopened as Hull New Theatre. In 2017 it was refurbished again in response to Hull being UK City of Culture.

There is a Ristorante da Peppino near Sant'Angelo on Ischia: http://dapeppino1954.com/

38. Boothferry Park, 1946

Boothferry Park was the home of Hull City FC from 1946 to 2002 when the club moved to the Kingston Communications Stadium. The stadium was first planned in 1929 but progress was nothing if not tortuous and the first game here did not kick off until 1946, dogged as it was by lack of money and the Second World War, during which the ground was used by the Home Guard, and requisitioned by the army to repair tanks. This had something of a detrimental effect on the playing surface. The opening match was against Lincoln City when 20,000 spectators came through the turnstiles. In 1948 the attendance record reached 40,179 for a game against Middlesbrough in the FA Cup, while 55,019 turned out in February 1949 to watch Hull play Manchester United, the all-time record. Hull FC is famous for Boothferry Halt, which opened in 1951. The railway station made its debut in a fixture against Everton when six trains plied between Paragon Station and Boothferry Park.

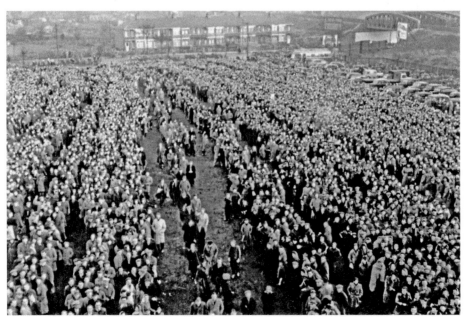

55,019 spectators turned out in February 1949 to watch Hull play Manchester United, the all-time record for the ground.

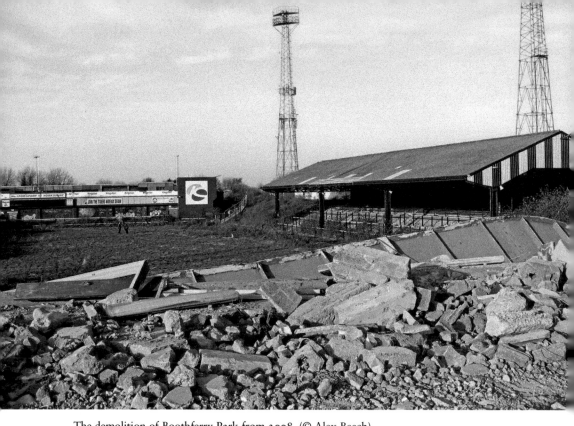

The demolition of Boothferry Park from 2008. (© Alex Beech)

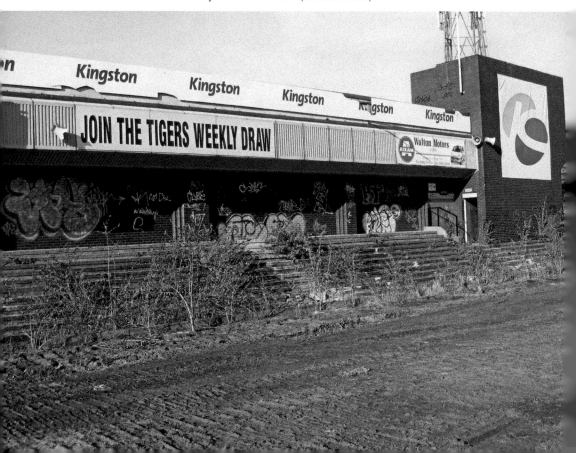

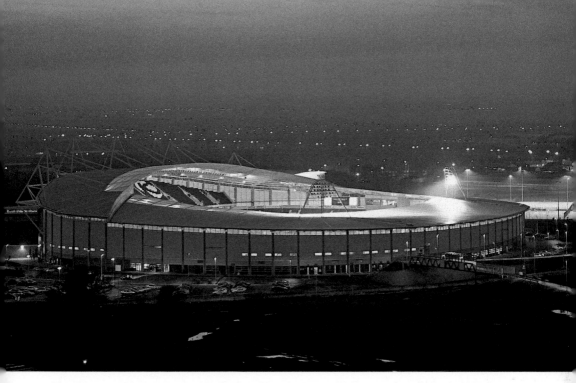

The Kingston Communication Stadium in Kingston-upon-Hull, viewed at dusk. (http://www. yorkshire-forward.com/www/imagebank.asp)

39. The Lawns, Cottingham, 1963

The Lawns is where close to 1,000 University of Hull students live in leafy Cottingham. It comprises seven halls of residence (Ferens, Lambert, Nicholson, Morgan, Downs, Reckitt and Grant) and the Lawns Centre – the catering and social hub. The halls are set in 40 acres of 'landscaped parkland'. There is a police station at the main entrance but this is not believed to be a reflection on the behaviour of the students. Ferens Hall, built in 1957, accommodates 191 students all in single rooms. It was established in the 1950s as a male-only hall of residence in a traditional rectangular style with rooms around three sides of a central lawn. All the other award-winning halls were designed by Gillespie, Kidd and Coia and comprise five blocks accommodating 140 or so residents. A typical block consists of three floors, with each floor housing nine students in seven rooms. Originally, all the halls were either male or female, but from 1985 they all became mixed.

The Lawns was developed on the site of the former Cottingham Grange, an army camp (Harland Way Camp) in the Second World War that also initially housed refugees; the Grange itself was used as officers' quarters. Ferens Hall was originally known as 'Camp Hall'. The house was demolished by the 1950s and the site split between the new Cottingham secondary school and Hull University.

As an example of the accommodation, Nicholson Hall was the fifth hall of the planned twelve halls of residence. It is named after John Nicholson, the principal of Hull University College, who in 1935 spearheaded the campaign to win the college's independence, finally achieved on 13 May 1954. Nicholson houses 142 students in both standard and en-suite rooms, all with balconies. It is the only self-catering hall at the Lawns and standard rooms

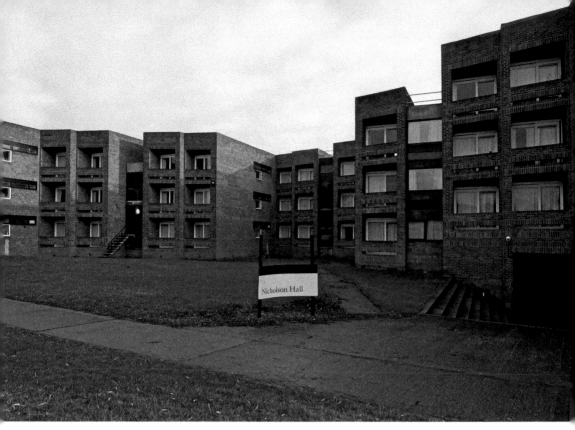

Above: Nicholson Hall at The Lawns in 2017.

Below: The Lawns Centre today.

Communal kitchen area in Nicholson Hall A Block, 1975. Left–right: Martin Cooper, Vince Gregory, Alan Lund, Ian Dickson, the author, Richard J Farrar. Photographer: Geoff Chalder MBE. (© Alan Lund)

have washbasins. In 2009 all double rooms were converted to singles, with updated kitchen-diner kitchens similar to those in Downs and Morgan Halls with additional en-suite facilities in some blocks. The hall was designated a Grade II-listed building in 1993. The author, and the book's three dedicatees, lived in Nicholson Hall between 1973 and 1976.

In the 1970s the Lawns Centre was a major venue for concerts, with acts such as Traffic, George Melly, Leo Sayer, Sparks and KC & the Sunshine Band appearing there.

40. Hull Royal Infirmary, 1967

Hull Royal Infirmary on Anlaby Road and Castle Hill Hospital in Cottingham are Hull's two principal hospitals. Before these, Hull General Hospital opened in a house in George Street in 1782 and in 1784 moved to a purpose-built building in Beverley Road, now

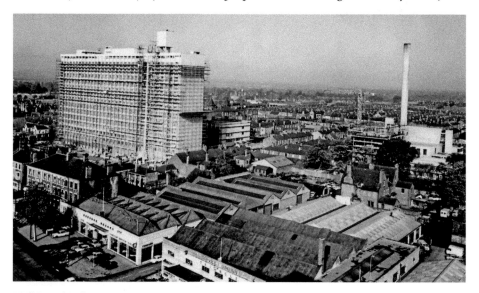

Hull Royal Infirmary going up in 1967.

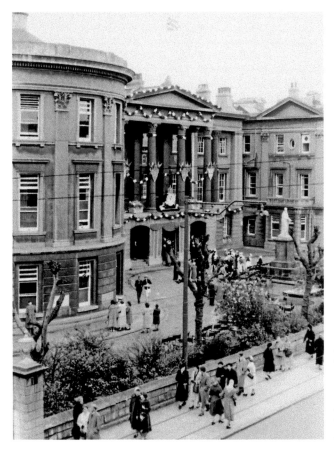

Left: The Royal Infirmary when it was in Prospect Street.

Below: Fundraising for the radiology department at Hull Royal Infirmary.

"Post The Past" postcard No.91
Medical History

RADIUM FOR ALL IS ROTARY'S CALL -
decorated lorries, Corporation Field, Park Street, Hull,
fundraising for the Infirmary c1932

Photograph reproduced by
permission of Ken Kaye, Hull

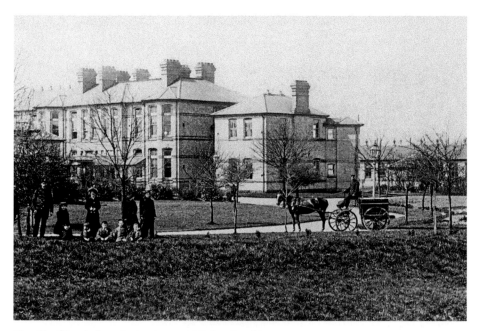

The City Hospital, or Sanitorium, on Hedon Road in 1885.

Prospect Street; by 1865 it had 150 beds. In 1884 the building was renamed Hull Royal Infirmary. The hospital relocated to Anlaby Road in 1967 in a building designed by architects Yorke Rosenberg Mardall. The thirteen-floor tower block accommodates most of the wards, as well as the Intensive Care Unit, pharmacy, laboratories and canteen. A four-storey building at the rear houses the Accident and Emergency department and Acute Admissions Unit, the High Dependency Unit, and radiology, as well as the operating theatres and most of the hospital's outpatient facilities. The East Riding Medical Education Centre and elements of the Hull York Medical School are located at Hull Royal Infirmary. The Prospect Street premises were demolished to make way for the Prospect Centre.

The City Hospital in Hedon Road was constructed in 1885, caring mainly for infectious diseases patients – hence its popular name, the Sanitorium. In 1928 it moved to Cottingham and the name changed to Castle Hill. Maternity services moved in to Hedon Road.

41. The Brynmor Jones Library, University of Hull, 1970

The imposing Brynmor Jones Library at the University of Hull contains over 1 million volumes. In 1967 it was named after Sir Brynmor Jones, a pioneer in research into liquid crystals at Hull, head of the department of chemistry in the 1930s and vice-chancellor of the university from 1956 to 1972.

The library really consists of two main parts: the older art deco-style entrance and five-floor front section from the 1950s, and the more recent extension, completed in 1970, which comprises eight floors and a basement. Philip Larkin was librarian here from 1955 until his death in 1985.

The Brynmor Jones Library,
University of Hull, 2017.

The library as it was in 1960.

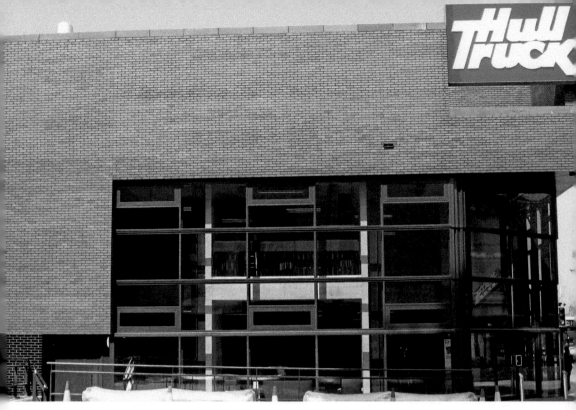

Hull Truck in 2009. (© Keith D.)

42. Hull Truck Theatre, 1971

In 1971 when actor Mike Bradwell found himself without work, he placed an advert in *Time Out* magazine, which read, 'Half-formed theatre company seeks other half'. He got his other half and then formed Hull Truck. The debut production *The Children of the Lost Planet* was a success but it led the company to concentrate on performing plays for children. However, in 1974 *Knowledge* was staged and, although over half the audience walked out, the critical acclaim of *Guardian* reviewer Robin Thornber led to the Bush Theatre stage production.

John Godber was appointed artistic director of Hull Truck in 1984 and wrote a play directly relevant to his audiences – *Up 'n' Under*, a production about rugby league in Hull proved a great success. His *Bouncers* celebrated its 30th anniversary in 2007 and was the final play to be performed before moving to the new venue – from Spring Street to a new 440-seat theatre as part of the St Stephen's development.

43. Hull Tidal Barrier, 1980

In 1980 this tidal barrier spanning the river was constructed at the mouth of the River Hull. A massive steel gate, weighing 202 tonnes, can be lowered into the river to seal the river from the Humber, preventing tidal surges from moving up the river where they routinely flooded parts of the city and the low-lying areas beyond. The gate is lowered between eight and twelve times a year and protects around 17,000 properties. In 2009, a £10-million upgrade took place, extending the life of the barrier until 2039.

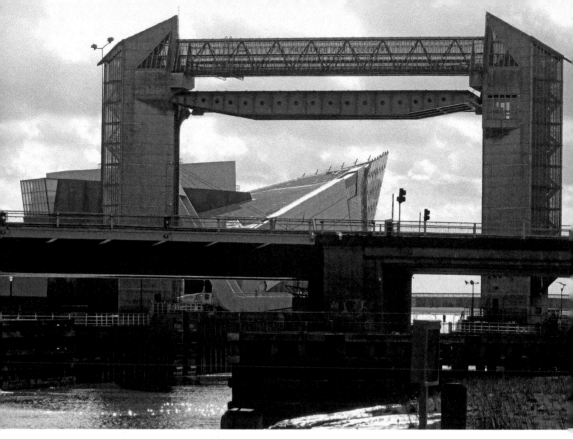

Above: Hull Tidal Barrier with The Deep in the background.

Below: Fun in the flooding in Oxford Street – Eleanor's Terrace, November 1953.

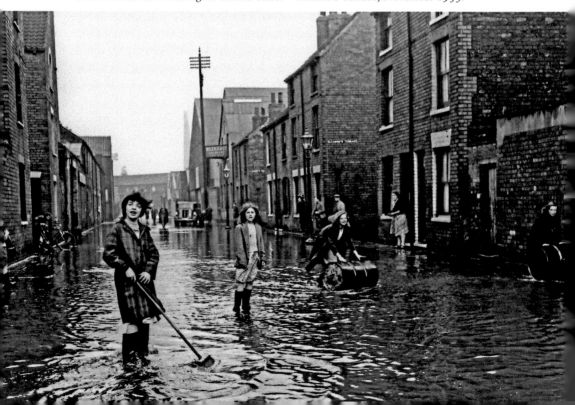

44. Hull Combined Court Centre, 1991

Opened in Lowgate in 1991, Hull's Combined Courts Centre assembled four Crown courts and one county court as well as ancillary accommodation under one roof.

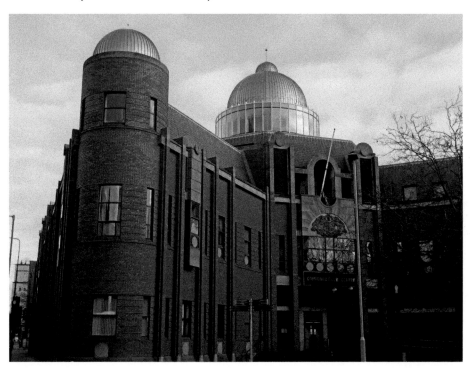

Hull Combined Court Centre in 2017.

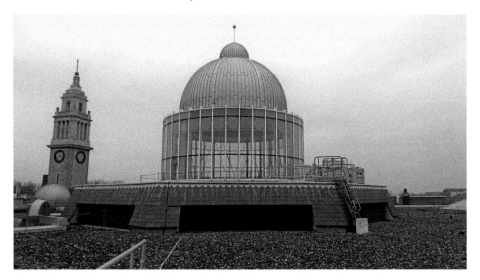

The glass roof observatory on the Court Centre.

45. The Deep, 2002

The Deep is without doubt, one of the world's best and most spectacular aquariums. No fewer than 3,500 fish can be seen swimming about here, including seven magnificent species of sharks, rays and northern Europe's only pair of green sawfish, along with fish that glow in the dark, coral, turtles, jellyfish, frogs, penguins, a flooded Amazon forest and numerous species of insects. Marine life apart, the tanks contain 2.5 million litres of water and 87 tonnes of salt. The Deep is the world's only 'submarium' – a building that is partly submerged in the water that surrounds it.

This architectural phenomenon is at Sammy's Point, which overlooks the Humber Estuary and its confluence with the River Hull. It was designed by world-famous architects Sir Terry Farrell & Partners and opened in 2002. Other Farrell projects include the MI6 building, KK100 in Shenzhen, the tallest building ever designed by a British architect, Beijing South Railway Station, at one time the largest railway station in Asia, Charing Cross Station, the new headquarters for the Home Office, and the conversion of the Grade I-listed Royal Institution of Great Britain.

In its first year a massive 850,000 visitors came through the doors of The Deep, making it busier than London Zoo. This helped finance a £5-million extension in 2005 to give extra exhibition space, retail, catering and education areas. Over 3 million people have visited The Deep since its opening. The Deep website tells us how,

> The building exploits the landscape on which it is built and was inspired by natural geological land formations. Gleaming glass and aluminium thrust into the dramatic landscape on the confluence of the two rivers marking the historic entry to Kingston upon Hull with a brand new future.

The Deep is also a cutting edge centre for marine research; the marine biologists here not only look after the animals in The Deep's collection but conduct research into the marine environment as well. Their work, in association with the University of Hull, extends from protecting endangered penguins in Antarctica to monitoring Manta Ray populations in the Red Sea.

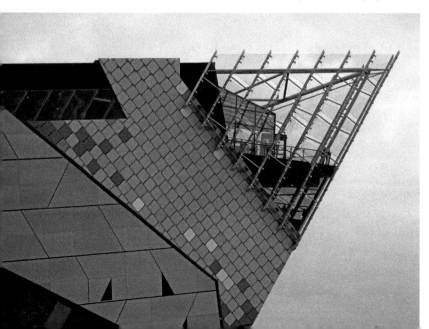

The Deep.

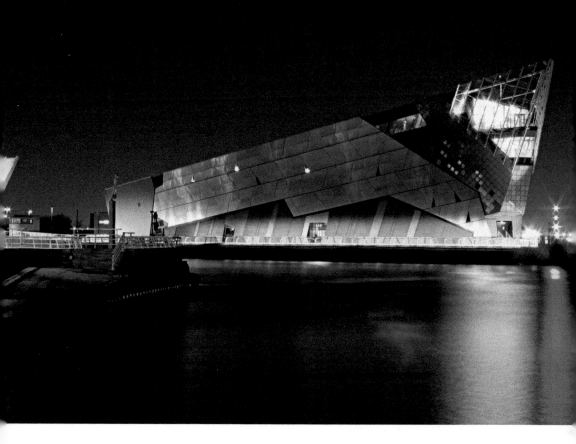

The Deep at night. (© Skyrider2688 under Creative Commons)

Sammy's Point goes back to the sixteenth century when Hull Castle was built here and parts of this were made into a new fortification, the Citadel, in 1681. During the construction of Victoria Dock in 1850, mud that was excavated for the dock was reused to extend the foreshore and create the land on which The Deep now stands. Sammy's Point is named after Martin Samuelson, who built a shipyard here in 1857. The land was once used by the Humber Conservancy as a buoy depot until the 1980s.

46. St Mary's College, 2002

St Mary's College is a mixed Roman Catholic secondary school and sixth form in Inglemire Lane, at the top of Cranbrook Avenue, formed from the then St Mary's Convent High School for Girls and Marist College for Boys. It was built in 2002 as a state-of-the-art sports centre for members of the school, and members of the public to use outside school hours. Originally St Mary's Grammar School, it was largely destroyed by bombs in 1941 after being established by the Sisters of Mercy close to a convent on Anlaby Road. It was later rebuilt and moved to Inglemire Lane in 1960 to become St Mary's Grammar School for Girls and Marist College for Boys.

St Mary's College today.

47. Hull History Centre, 2010

This fantastic resource uniquely draws together the collections of the Hull City archives, Hull University archives and the Local Studies Library. Hull is the first city in the UK to unite local council and university collections under one roof. The building was designed by Pringle Richards Sharratt, and the aim was to provide 'a highly accessible and visible structure, as well as a focus of local pride. The design of the upper floor features an environmentally controlled repository while the ground level features public spaces adjoined by a linear arcade overlooking a new park'. If you were to line up the collections (books and journals and magazines, maps, paintings, photographs, pamphlets and film), they would extend across the 2,220-metre-long Humber Bridge four times.

Here is a small selection of the archives in the collection:

Modern political papers including John Prescott, Kevin McNamara, Austin Mitchell, Chris Mullin; Modern English literary manuscripts including Philip Larkin, Douglas Dunn and Alan Plater; Business Records including Ellerman's Wilson Line and the Hull & East Riding Co-operative Society; Religious archives including local Quaker records, some papers of Selby Abbey and Marrick Priory; the City Council collections including the royal charter of 1299, issued by Edward I, which established the city of Kingston upon Hull; Watching, Lighting, Cleansing and Paving Authorities; Boards of Health; School Boards; Poor Law Authorities; documents from the Hull Borough Asylum, the Hull Gas and Light Co. and the Newington Water Co.; a collection of over 9,000 loose illustrations including drawings, prints, photographs, postcards and framed paintings; theatre bills and programmes, posters, football programmes, postcards, timetables, tradesmen's publicity; special collections including William Wilberforce and Slavery, Andrew Marvell (1621–78), Whales and Whaling, Winifred Holtby (1898–1935) and Amy Johnson.

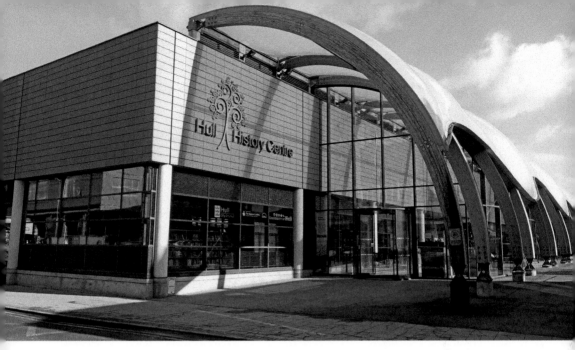

Hull History Centre, March 2017.

48. Kingswood Academy, 2013

This £25-million building on the Bransholme housing estate was named as one of the best buildings in the UK by the Royal Institute of British Architects (RIBA). Facilities include a professional theatre and recording studio, a full-size 4G football pitch, dance and drama studios, and a state-of-the-art design and technology workshop. The 1,350-pupil-capacity school was designed by Allford Hall Monaghan Morris, and built by the 'Esteem Consortium' with Morgan Sindall as the main construction contractor. In 2016 the academy educated 588 pupils.

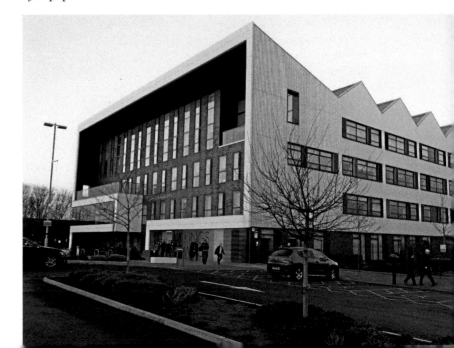

Kingswood
Academy,
Bransholme.

49. The Allam Medical Building, University of Hull, 2017

The centrepiece of the state-of-the-art £28-million world-class Health Campus is the five-storey Allam Medical Building, which will soon accommodate the Hull York Medical School. It will feature a mock hospital ward, operating theatre and intensive care facilities, as well as research space. The building, which is partly funded to the tune of £7 million by Dr Assem Allam, chairman of Hull City FC, will also house a large lecture theatre and a ground-floor atrium and cafe. As well as the Hull York Medical School, the campus will include the Faculty of Health and Social Care, and Sport, Health and Exercise Science and establish a new Institute for Clinical and Applied Health Research.

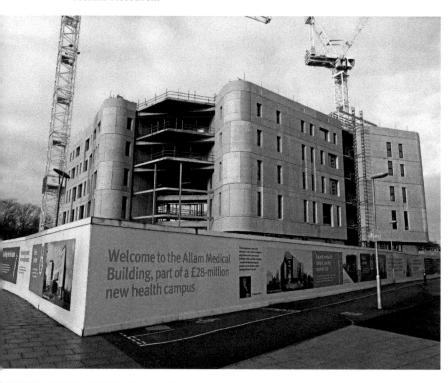

The Allam Medical Building, University of Hull, 2017.

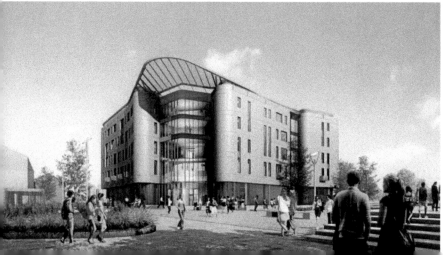

An artist's impression of the finished building.

50. The Blade, 2017

In January 2017 a truly unique structure came to Queen Victoria Square as a gift from Siemens to form part of Hull's role as UK City of Culture. Transporting the huge wind turbine blade from the Siemens Alexandra Dock factory to the city centre was a massive logistical exercise: the blade measures 75 metres in length and is 3.5 metres wide at its base, or 'root', and it weighs 25 tonnes. However, due to Siemens' unique manufacturing, this blade is actually 20 per cent lighter than a traditionally engineered offshore wind turbine blade. There are no seams or glued joints and no adhesive. The Hull-made blades are the world's largest fibreglass components cast in one single piece and they are made from fibreglass, balsa wood and reinforced epoxy resin.

The Blade is mounted 5.5 metres from the ground at its highest point, allowing buses to pass underneath. The exhibit was conceived by Nayan Kulkarni, who is also responsible for a number of UK City of Culture projects illuminating historic buildings across the city centre. Nayan describes it as 'a profound material gesture, a spectacle, an obstacle and an object of wonder.' On 18 March 2017 it returned to the Siemens site on Alexandra Dock.

The Blade being erected in Queen Victoria Square in January 2017 – 75m in length.

The Blade in situ, March 2017.

Timeline of Hull

c. 1193 Local monks establish a port where wool from their estates can be exported. It was called Wyke on Hull.

1279 Hull is granted the right to hold a market and a fair

c. 1285 The Church of the Holy Trinity is built

1293 Edward I acquires Hull. It is now Kingston upon Hull.

1295 Hull's Parliamentary representation starts

c. 1300 A mint is established in Hull

1331 Hull is given a charter

1349 The Black Death ravages Hull

c. 1365 A weigh house to weigh bales of wool is built

1369 Hull was bounded by the Rivers Hull and Humber, on the west by what is now Prince's Dock Side and Humber Dock Street, and Queens Gardens on the north side. There were five gates by which one could gain entry to the walled town: the Main Gate, Beverley Gate, was located at the west end of what we now know as Whitefriargate

1369 Trinity House for seamen is established

1384 Charter-House Hospital founded

1486 Grammar school founded

1536 The Pilgrimage of Grace. Rebels enter Hull and then are transported to York to hang.

1537 Plague strikes Hull again

1541 Henry VIII improves the town's defences

1575 Plague strikes Hull again and again in 1602–04 and 1637

1642 Charles I is refused entry to Hull. The royalists lay siege to Hull but fail to capture it; same again in 1643

1700 The population of Hull is around 7,500

1716 Trinity House Marine School founded

1743 Hull opens its first theatre

1744 Maister House is built

1755 Improvement Commissioners given powers to pave, clean and light the streets of Hull

1759 William Wilberforce is born in Hull

1773 Hull Dock Co. formed

1775 Hull Subscription Library established.

1780 William Wilberforce becomes the Member of Parliament for Hull

1778 First dock opens in Hull

1782 Hull Royal Infirmary opens

1800 The population of Hull now is around 22,000.

1809 Humber Dock is built

1814 A dispensary where the poor can obtain free medicines opens

1822 Hull gets gas street lighting

William III, William of Orange (r. 1689–1702). This impressive gilded statue was erected in 1734.

1829 Junction Dock is built. United Gaol and House of Correction opens. Prince's Dock is built. St Charles Borromeo Church opens

1832 Cholera epidemic in Hull

1836 Police force established

1840 Hull & Selby Railway begins operating. Zoological Gardens open

1850 Victoria Dock is built.

1851 Population is 57,484

1854 Royal Institution opens. Hull & Holderness Railway begins operating

1860 Pearson Park opens its gates

1861 Hull School of Art founded

1865 Hull FC founded

1866 Town Hall built

1870 HM Prison Hull opens

1875 Trams start running

1880 Botanic Garden opens. Telephone exchange opens in Hull

1881 Hull Philharmonic Society founded. Smallpox kills 689 people in Hull

1882 Kingston Amateurs rugby club formed

1885 Hull & Barnsley Railway starts to run. Alexandra Dock built. *Hull Daily Mail* begins publication

1886 A synagogue is established

1894 Central Library opens in Hull
1897 Hull becomes a city
1901 The population of Hull is 239,000
1906 Wilberforce and Historical Museum opens
1909 Hull City Hall built
1911 Theatre De Luxe opens.
1912 Museum of Fisheries and Shipping, and Coliseum Theatre open
1915 Pavilion Picture Palace opens. A Zeppelin raid kills twenty-four people in Hull
1927 University College Hull established. Ferens Art Gallery opens
1931 Population reaches 309,158
1935 Queens Gardens are laid out
1937 Trolleybus' begin trundling
1939 Hull New Theatre opens.
1939–45 The Second World War. Around 87,000 houses are destroyed by German bombing
 and 152,000 were homeless
1946 Boothferry Park opens
1954 Hull University is founded
1971 Hull Truck Theatre founded
1972 Hull City Council established
1976 Streetlife Museum opens
1981 Humber Bridge opens. The population is 266,751
1990 Princes Quay Shopping Centre opens
1997 RED Art Gallery opens. Hull and East Riding Museum opens.
1999 The *Arctic Corsair* opens to the public
2001 The Deep opens up in Hull
2002 KC Stadium opens
2003 Hull York Medical School takes in its first students
2007 Hull Paragon Interchange transport complex and St Stephen's Hull shopping centre open
2010 Larkin 25 fest held
2017 Hull is UK City of Culture

Drypool Bridge, which opened in 1961, with its 2017 makeover to celebrate John Venn (1834–1923), logician and inventor of the Venn diagram, who was born in Drypool.